DREADFUL FIRE! Burning of the Houses of Parliament

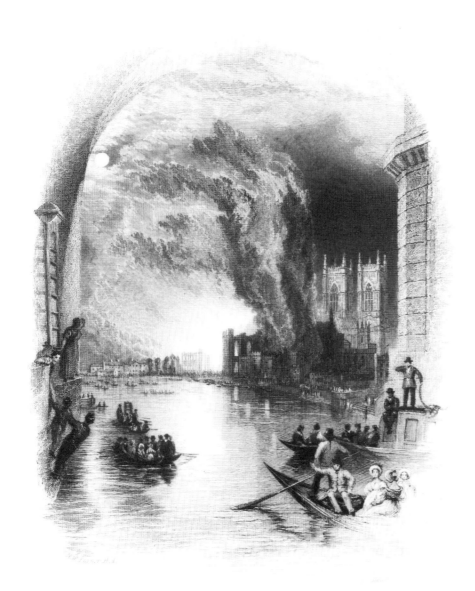

Dreadful Fire!

BURNING OF THE HOUSES OF PARLIAMENT

Katherine Solender

THE CLEVELAND MUSEUM OF ART

Published by The Cleveland Museum of Art in cooperation with Indiana University Press,
Tenth and Morton Streets, Bloomington, IN 47405

Manuscript editing by Jo Zuppan.
Design by Merald E. Wrolstad.
Typesetting, printing, and binding by Tecnicom Corporation, Solon, Ohio.

Cover. Detail of *Burning of the Houses of Parliament.* [12]. J. M. W. Turner. The Cleveland Museum of Art, Bequest of John L. Severance, 42.647.
Frontispiece. *Destruction of Both Houses of Parliament by Fire Oct^r 16, 1834,* after J. M. W. Turner [14]. James Tibbetts, engraver. Freiberger Library.

Photograph credits

John Freeman & Co. (Photographers) Ltd.: Figures 35, 51.
Godfrey New Photographics Ltd.: Figures 18, 21-23, 25-29, 31, 45, 46.
Nicholas Hlobeczy: [1-5], [12], [14], [16]; Figures 20, 30, 32, 34, 36, 47.
Eric E. Mitchell: [11].
Sydney W. Newbery: [13].
Robert Wallace: Figure 3.

Numbers enclosed in square brackets [] refer to catalogue entries.

Library of Congress Cataloging in Publication Data

Solender, Katherine, 1954-
 Dreadful fire! Burning of the Houses of Parliament.

 Catalog of an exhibition.
 Bibliography: p.
 1. Art, British—Exhibitions. 2. Art, Modern—19th
century—Great Britain—Exhibitions. 3. Great Britain.
Parliament. House of Commons—Buildings—Exhibitions.
4. Great Britain. Parliament. House of Lords—
Buildings—Exhibitions. 5. Buildings in art—
Exhibitions. 6. Fire in art—Exhibitions. 7. Turner,
J. M. W. (Joseph Mallord William), 1775-1851—
Exhibitions. I. Cleveland Museum of Art. II. Title.
N6767.S6 1984 759.2 84-17616
ISBN 0-910386-74-9

Foreword

Joseph Mallord William Turner was an artist of infinite ability. With the probable exception of Pablo Picasso, no other artist in the history of European art has been as produc-. tive. First exhibiting at the Royal Academy in 1790, when he was only fifteen years old, he continued showing great numbers of pictures there and elsewhere until 1850, the year before his death. His work, essentially landscape, presented an awesome evolution which aroused in his contemporaries successively admiration, then consternation, and finally near-adulation as he broadened his understanding and interpretation of the world around him. His work repeatedly pushed contemporary perceptions to new extremes.

His pictures, even at their most radical, were based always upon a sound and methodical understanding of nature. In thousands of pencil sketches and in great numbers of watercolor notations, he studied the many specific details or, increasingly, the larger effects that aroused his interest as he traveled throughout England, Wales, and Scotland and then to those places on the Continent which attracted travelers because of their natural beauties or their architectural interest. At the outset, in his sketches, he would record details that he wished to recall later with precision—the complexity of an arcade's tracery, for example. More and more, however, he came to concentrate upon those salient details of a big vista which, when compressed to the dimensions of a picture, would nonetheless capture an almost superhuman largeness of vision which a person, actually standing before the scene, could hardly hope to grasp in a glance. Thus in his late work he achieved a remarkable freedom that made it possible to suggest the emotions a scene might arouse in the viewer rather than merely describe its pedestrian details. But, most interestingly, even as he pursued the larger scene, he was always aware of the typical day-to-day activities of the local inhabitants going on in the foreground.

The two paintings inspired by the horrendous fire that largely destroyed Britain's Houses of Parliament in the course of one October night are among his most stirring achievements. They come at a turning point in his career. In the years immediately preceding the fire, he had been making a series of daring studies in which color broadly treated was the sole means of exression. By making those studies on a blue paper rather than the usual white paper and by using an opaque gouache rather than transparent watercolor, he achieved an even greater brilliance of color. A series of vignettes of the Seine and the Loire rivers—designs carefully planned to be recreated as engravings—and then a group of more spontaneous, purely private studies, made on the grounds of his friend Lord Egremont's country seat, Petworth, certainly nurtured a flexibility of attitude that surely gave him the freedom to respond to the Thames-side tragedy with the intensity appropriate to the event.

The two great oil paintings and the related preliminary studies as well as the vignette (subsequently created as the basis for a steel engraving) present an opportunity without equal to study in some depth the complexities of Turner's working methods. By the mid-1830s his control of his means was such that the master's hand moved with a speed virtually in tandem with his thought processes. Indeed tradition has it

that the Philadelphia picture was largely completed while already hanging on the walls of the British Institution in the day or so before the opening of the 1835 exhibition.

This present publication was planned by the Museum's previous Director, Sherman E. Lee, and the Curator of Art History and Education, James A. Birch, as the first of a series of in-depth examinations of certain outstanding masterpieces in the Museum collection. Even as Katherine Solender worked on her material, Evelyn Joll—the Chairman of Thomas Agnew & Son, who with Martin Butlin wrote the standard catalogue of Turner's paintings—pointed out the importance of 1984 as the 150th anniversary of the dreadful fire. The Cleveland Museum of Art and the Philadelphia Museum of Art, therefore, agreed that this would be an appropriate time to exhibit the two paintings together, only the second time in their history that they have been shown side by side. The British Museum in turn also generously agreed to lend some of the related sketchbook material. Happily the watercolor vignette had recently emerged and been acquired by an American collector who agreed to cooperate as well.

It is not without interest that as Ms. Solender pursued her research on Cleveland's painting, other scholars also began to explore various aspects of these works. Richard Dorment's pivotal research, which is to be published in his forthcoming catalogue of the British paintings in the collection of the Philadelphia Museum of Art, as well as subsequent writings by Andrew Wilton and John Gage, have complemented Ms. Solender's research and made it the richer.

Evan H. Turner

Acknowledgements

Preparations for this catalogue and the exhibition it accompanies began more than four years ago, when Sherman E. Lee, then Director of The Cleveland Museum of Art, originated the idea of a show focusing on a single outstanding object in the Museum collection, placing it in both its artistic and historic context. I selected Turner's *Burning of the Houses of Parliament,* not only because of the interest that this extraordinary painting always arouses in Museum visitors but also because the event it depicts is so compelling. When Evan H. Turner arrived as Director of the Museum in July 1983, he brought with him a fresh infusion of enthusiasm and encouragement that gave my work added impetus. Dr. Turner has long maintained a deep personal and scholarly interest in this artist, and it is only through his involvement that this dual commemoration of both J. M. W. Turner and the 150th anniversary of the Parliament fire has been made possible. I am deeply grateful for the fervor with which he supported this endeavor.

The success of this undertaking was also made possible by the significant measure of assistance I received from many other individuals on the Museum staff. My thanks go to all of them. Special mention must be made, however, of James A. Birch, curator of the Department of Art History and Education, whose constant advocacy is most warmly appreciated. I also owe a tremendous debt to the generosity of Janet Leonard, assistant to the curator, who not only typed the manuscript, but also guided me through the labyrinthine details of organizing an exhibition. John Schloder, assistant curator in the Education Department, contributed numerous useful suggestions along the way, and Bernice Spink, assistant

for scheduling, provided invaluable proofreading assistance. A very special note of thanks goes to Marjorie Williams, associate curator of art history and education, who devoted many hours to a painstaking reading of the manuscript. I am deeply grateful for the sensitivity she showed to my ideas and the graceful manner in which she offered her wise advice. Also especially helpful and somehow always cheerful during the preparation and production of the catalogue was Jo Zuppan, the Museum's associate editor, while Chief Editor Merald Wrolstad was responsible for its design. I would also like to thank Georgina Gy. Toth, associate librarian for reference, whose expertise with inter-library loans greatly facilitated my research.

As for the exhibition itself, I owe thanks to Louise Richards, chief curator of the Department of Prints and Drawings, for the loan of six prints to the exhibition, and Jane Glaubinger, assistant curator, for her patience in answering my questions about them. The logistics of transporting the loans from other institutions were ably handled by Delbert Gutridge, Museum registrar, and Carol Thum, assistant registrar. The exhibition was installed under the expert supervision of William E. Ward, chief designer.

One of the pleasures of this project has been the new contacts it has brought me outside the Cleveland Museum. I am happy to acknowledge the many kind people from the various museums, galleries, and libraries—both American and British—who helped me bring this exhibition and publication together. Among those to whom I am especially grateful are Andrew Wilton of the British Museum, Joseph Rishel of the Philadelphia Museum of Art, Evelyn Joll of Agnew's

(London), Celina Fox and I. E. Shaw of the Museum of London, and Ann Drain of Freiberger Library (Case Western Reserve University, Cleveland). Much of my research would not have been possible without the gracious cooperation of Margaret Swarbrick of the Archives Department, Westminster City Libraries, London. Information or suggestions were also most generously given by John Gage, Richard Dorment, Marianne Doezema, Charles Stuckey, and Norma Guyon. Special acknowledgement goes to Eric Shanes, who very kindly read parts of my first draft and offered valuable advice and deeply appreciated encouragement.

I would also like to thank all of the institutions permitting pictures in their collections to be reproduced in the catalogue and the exhibition. And, of course, I am indebted to the Trustees of the British Museum, the Philadelphia Museum of Art, the Walters Art Gallery, Freiberger Library, and the Museum of Outdoor Arts for their loans to the exhibition.

Finally, my sincerest thanks go to my family and friends for their faith, forbearance, support, and encouragement right from the start. And most of all, I wish to thank my husband, William Katzin, whose unlimited patience, understanding, and love never cease to amaze me.

K. S.

Contents

COLOR PLATES

Following page 40
Burning of the Houses of Parliament [7] (British Museum, TB CCLXXXIII-5)
Burning of the Houses of Parliament [10] (British Museum, TB CCCLXIV-373)

Following page 56
Burning of the Houses of Parliament [11] (Philadephia Museum of Art, M'28-1-41)
Burning of the Houses of Parliament [12] (The Cleveland Museum of Art, CMA 42.647)

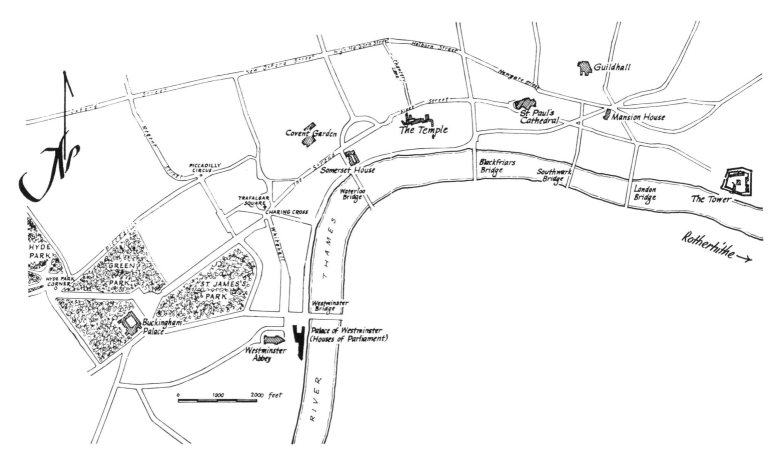

City of London and Westminster: Major Landmarks.
After Aldon Bell, *London in the Age of Dickens*.
Copyright 1967 by the University of Oklahoma Press.

Introduction

Ruined and gone! How like a feverish dream
The pictured glare upon that peopled stream!
The wild confusion, and the startled cry,
The smoky columns blotting out the sky,
The pale sick moon, the busy hurrying crowd,
And the tall distant Abbey, nobly proud—
All this was real!

"The Burning of the Houses of Lords and Commons,"
The Keepsake (London, 1835), lines 1-7.

On the night of October 16, 1834, a fire broke out in the ancient Palace of Westminster located on the Thames River in London. Few people will forego the chance to witness a truly spectacular fire, so it is no wonder that an excited throng of Londoners converged on the neighborhood, jamming the surrounding streets, the bridges, and even the river in order to witness the awe inspiring sight.

Given the commanding visual drama of billowing smoke and flames bursting forth against the moonlit sky, it is also not surprising that numerous artists were in that crowd.[1] In fact, the porter of the Royal Academy supposedly announced the event to students in the library: "Now, gentlemen; now, you young architects, there's a fine chance for you; the Parliament house is all afire."[2] Charles Barry (1817-1860), the architect ultimately responsible for rebuilding the Houses of Parliament, was on his way to London from Brighton when the fire broke out. He, too, rushed to Westminster in time to take his place among the multitude, his imagination already fixed on the "conception of designs for the future."[3] Another architect who would play a significant role in the design of the new Houses of Parliament, Augustus Welby Pugin (1812-1852), also witnessed the fire. He later commented that its effects were "truly curious and awfully grand."[4] At some time during the evening the respected landscape painter John Constable (1776-1837) also viewed the spectacle, sitting in a hackney coach on Westminster Bridge with his two eldest sons. He later made an ink sketch of the fire from memory which, along with some watercolors of the catastrophe, is still in his family's possession. Although impressed by the fire, Constable never felt compelled to record it in oil.[5]

In contrast, the destruction of the Houses of Parliament triggered a deeply felt response in Constable's great contemporary, J. M. W. Turner (1775–1851). Also an eyewitness to the fire, Turner spent most of the night intently observing the historic disaster. The result appears to have been a significant body of work including two sketchbooks, a watercolor, a vignette, and two major oil paintings, both entitled *Burning of the Houses of Parliament*. One of them is in the collection of the Philadelphia Museum of Art and the other in The Cleveland Museum of Art. This book brings these works together and examines them within the context of both the artist's career and the facts of the event they commemorate. The drawings and paintings Turner produced in the aftermath of the Parliament disaster reveal not only the profound impact that it had on him but also the very process through which he arrived at an expressive union of experience and imagination.

Figure 1. J. M. W. Turner. *The Pantheon, The Morning after the Fire.* Watercolor over pencil, 15-1/2 x 20-1/2 inches, 1792. London, Trustees of the British Museum, TB IX-A.

Figure 2. J. M. W. Turner. *The Ruined Interior of the Pantheon, Oxford Street.* Pencil, pen and brown ink, and watercolor, 9-1/8 x 11-5/8 inches, 1792. Trustees of the British Museum, TB IX-B.

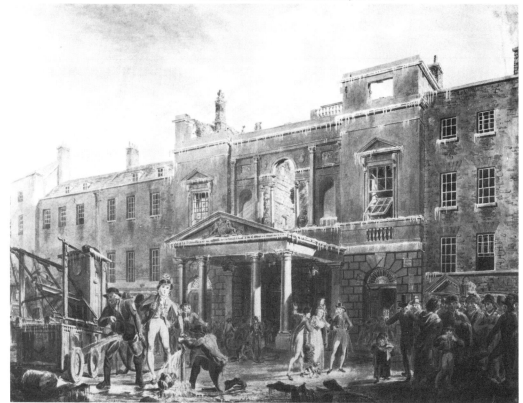

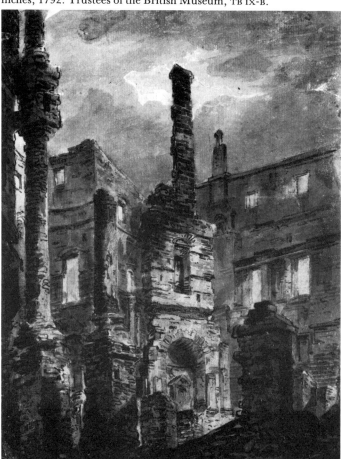

PART ONE J. M. W. Turner: Life and Art

Joseph Mallord William Turner was born on April 23, 1775, at 21 Maiden Lane, Covent Garden—within easy walking distance of the Palace of Westminster and the Thames. His father, William, was a barber and wigmaker. His mentally unstable mother, Mary, eventually became so violent that she had to be committed to Bethlehem Hospital in 1800. Four years later she died in a private asylum. During his childhood years, Turner developed a very close relationship with his father, who encouraged his artistic inclinations and proudly exhibited his son's early drawings for sale in the window of his barbershop.

Although he acquired technical skills by working with various masters for short periods, Turner basically taught himself, starting his career as a topographical draftsman and copyist of other artist's works. By the end of 1789, when he was only fourteen, his skill in architectural renderings, coastal scenes, and landscapes had merited enough recognition to justify his admission into the schools of the Royal Academy. He exhibited at the Academy for the first time in 1790, showing a watercolor, *The Archbishop's Palace, Lambeth* (Indianapolis Museum of Art, Indianapolis, Indiana), and received favorable notice from the critics.

Continuing to exhibit his topographical work, Turner also displayed his propensity for interpreting topical events when he submitted *The Pantheon, The Morning after the Fire* (Figure 1) to the Royal Academy's annual exhibition two years later. This watercolor shows the aftermath of a fire, early in 1792, that destroyed a concert hall on Oxford Street, London.[1] Turner studied the scene the day after the fire and then painted this view which has the ravaged, icicle-covered building as its ostensible subject. The figures which take up the foreground of the composition are, however, just as interesting for they reveal the human response to the calamity. At the right spectators gesture excitedly, recounting the events of the previous night, while to the center and left the firemen busily clean their equipment before leaving. Thus the consequences of nature's destructive power are rendered in human terms. The introduction of figures to give life to a scene and explain it would become a constant feature of Turner's art.

Turner also depicted the destruction inside the ruined Pantheon with an interior view showing the charred, skeletal forms of the still-standing masonry enveloped in an atmosphere tinged with lingering smoke (Figure 2). Although he used no figures in this scene, Turner has still managed to suggest his reactions to the scene rather than merely record its appearance. Here there is no mistaking the gloom settling over the ruins of what was once a festive backdrop for pleasurable entertainments.

During the 1790s Turner went on the first of a long series of summer hiking and sketching tours that eventually led him throughout England, Scotland, and Wales in search of picturesque landscape views and architectural subjects. He especially concentrated on the great medieval cathedrals which were then such popular subjects with the public. With the material he gathered on these trips, Turner built up a great repertoire of motifs for later use. Frequently the pencil sketches he made while traveling would be worked up into finished watercolors and sold to private collectors or to publishers for engraving. Often the information in the sketchbooks would be incorporated into oil paintings. In 1802, when the Treaty of Amiens temporarily halted England's war with France, Turner's sketching tours extended to the Continent,

beginning with a trip to Parıs, the French Alps, and Switzerland. After 1817, when the hostilities finally ended, Turner visited Europe with greater frequency. For the rest of his life the topographical material gathered on his travels remained an important source of income. He stopped traveling, hiking, and sketching only when prevented by age and poor health.

Another important factor in Turner's early development was his employment, from 1794 to 1797, by Dr. Thomas Monro (1759-1833), chief physician at Bethlehem Hospital. Monro, a well-known connoisseur of drawings, helped educate young artists by paying them to copy works in his collection. With his leading competitor, Thomas Girtin (1775-1802), Turner spent his evenings, copying drawings by a number of prominent watercolorists, among them John Robert Cozens (1752-1797). Turner learned important tech-

nical lessons from Cozens's work, especially a method for rendering compositions with only tonal variations that eliminated the need for outlines. Cozens's depictions of romantic scenery in Italy and Switzerland also conveyed an imaginative power which soon figured prominently in Turner's own work as it evolved from factual topographical recordings to more expressive interpretations of nature's moods.

Although Turner worked in watercolor throughout his career, he realized early on that only through large-scale oil painting would his artistic ambitions be realized. With election to the Royal Academy in mind, he exhibited in 1796 his first work in oil, a moonlit scene entitled *Fishermen at Sea* (Tate Gallery, London). The rapid development evident two years later in *Morning amongst the Coniston Fells, Cumberland* (Tate Gallery) and *Buttermere Lake with Part of Cromackwater, Cumberland, a Shower* (Tate Gallery) in 1798 won him election as an Associate Member of the Royal Academy the following year, at the age of twenty-four. Remarkably, he was elevated to the status of full Academician within three years. Further honors were bestowed upon him in 1807 when he was elected Professor of Perspective, a post he held for some thirty years, despite the highly irregular schedule of his six-lecture course. Although not a polished speaker, he used large and often intricate drawings and diagrams to accompany his talks, and they made his course quite popular among Royal Academy students.

By the late 1790s Turner's conception of what constituted an emotionally and artistically significant painting had begun to take shape. In 1799 his entries in the Royal Academy exhibition included the *Battle of the Nile*,[2] his first exhibited oil depicting a contemporary event—Admiral Nelson's decisive defeat of the French fleet in Aboukir Bay, Egypt, during the previous summer. Turner apparently portrayed with great effect the culmination of the battle, the blowing up of *l'Orient*, the French munitions ship. Although the painting is now lost, something is known of it from contemporary reviews. *The Morning Post* for May 11 commented favorably on the "irresistable fury" of the fire and the "blackening volumes of smoke above."

Figure 3. J. M. W. Turner. *The Fifth Plague of Egypt*. Oil on canvas, 49 x 72 inches, exh. 1800. Indianapolis Museum of Art, Gift in memory of Evan F. Lilly, 55.24.

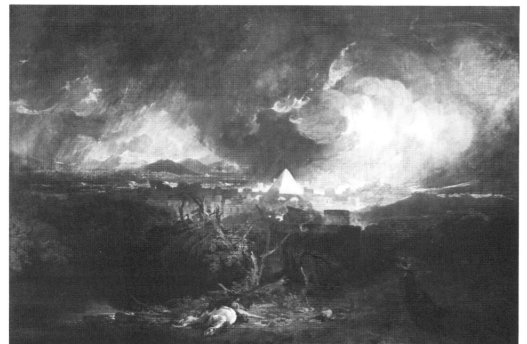

14

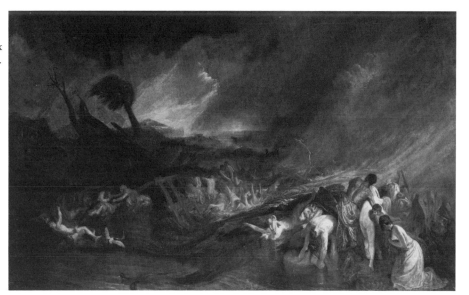

Figure 4. J. M. W. Turner. *The Deluge*. Oil on canvas, 56-1/4 x 92-3/4 inches, exh. 1805. London, The Tate Gallery, 493.

The *Battle of the Nile*, though well received, illustrated a contemporary event and thus did not reveal Turner's ability to conceive more elevated subjects. In 1800 he exhibited his first truly historical picture,[3] *The Fifth Plague of Egypt* (Figure 3), which was followed in 1802 by *The Tenth Plague of Egypt* (Tate Gallery). Both of these works reflect Turner's desire to endow the art of landscape with the status previously accorded only to history painting, then regarded as the highest branch of art. *The Fifth Plague of Egypt*, for example, the largest canvas he had yet painted, was shown with a quotation from Exodus, 9:23, ''And Moses stretched forth his hands toward heaven, and the Lord sent thunder and hail, and the fire ran along the ground.''[4] In the painting, the figure of Moses is dimly visible at the right, while shattered trees and dying men and horses are highlighted in the center foreground. In the midground, the city burns; raging flames and billowing smoke mingle with the clouds above. In the distance ominous bursts of light illuminate remote hills. As is characteristic of his later works, Turner presented this scene of ravaged nature and doomed humanity with an expressive power achieved through his poetic imagination, nourished by personal experience and a remarkable visual memory. The cataclysmic combination of boiling clouds and flashes of lightning may have been based on a storm he had observed and sketched three years earlier in Wales.[5]

In 1803 Turner exhibited the dramatic *Calais Pier, with French Poissards preparing for Sea: an English Packet arriving* (National Gallery, London) in which he recalled a stormy scene he had witnessed upon first landing in France the previous year. *Calais Pier* was one of Turner's first great marine paintings, and although it was criticized for lacking definite forms and details, it created a sensation at the Royal Academy.

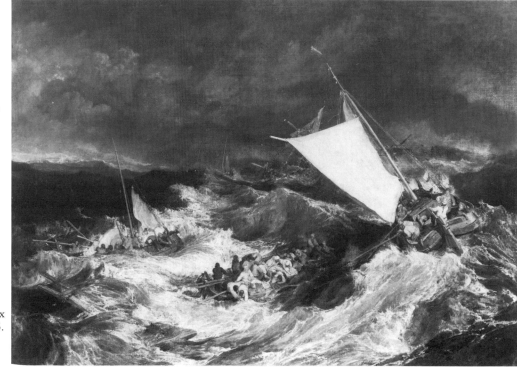

Figure 5. J. M. W. Turner. *The Shipwreck*. Oil on canvas, 67-1/8 x 95-1/8 inches, exh. 1805. The Tate Gallery, 476.

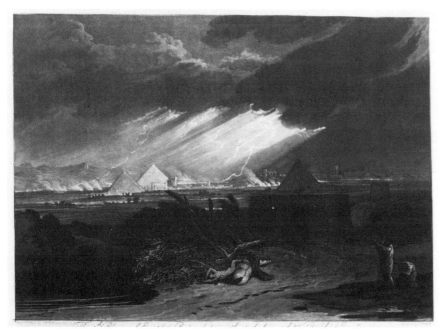

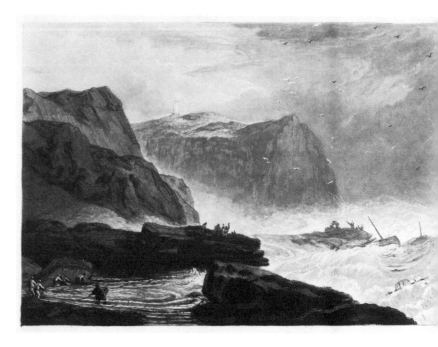

1 *The Fifth Plague of Egypt*.
J. M. W. Turner. The
Cleveland Museum of Art,
CMA 19.135.

2 *Coast of Yorkshire Near
Whitby*. J. M. W. Turner. The
Cleveland Museum of Art,
CMA 19.141.

This same year Turner became a member of the Academy's governing council and was immediately drawn into its internal struggles. Two factions, the ''Court Party'' and the ''Democrats,'' were quarreling so bitterly over the relative power of the council and the General Assembly (all forty Academicians) that it seemed that the Academy might not hold together. This may have prompted Turner to open a gallery of his own in 1804, behind his house at 64 Harley Street, London. He later enlarged the gallery and transferred the entrance to Queen Anne Street, around the corner. Showing his work there not only supplemented the Academy exhibitions but also became the chief means for selling his own paintings.

In 1805 Turner exhibited two more pictures that, like the earlier Plague pictures and *Calais Pier*, satisfied the contemporary taste for ''sublime'' subjects, that is, horrifying or fearful representations of the elements. *The Deluge* (Figure 4), which was exhibited at the Royal Academy, and *The Shipwreck* (Figure 5), which was shown at Turner's own gallery, are both filled with sweeping circular and diagonal movements and dramatic contrasts of light and dark. They also reveal Turner's fascination with the sea and man's desperate struggle in the face of its annihilating power. As was so often the case personal experience became the point of departure for *The Shipwreck*, since he may have returned once again to sketches of his journey to France in 1802 and perhaps sketches of wrecks he made in 1803 or 1804.[6] The elemental force of the tempestuous water is conveyed by the disparity in scale between the struggling, powerless figures and the thunderous, foaming waves, which, relative to those in Turner's earlier marine subjects, are convincingly represented with a profusion of thick white paint.[7]

16

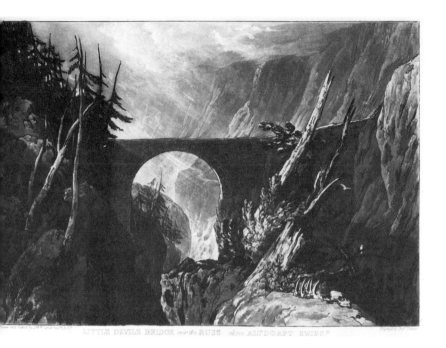

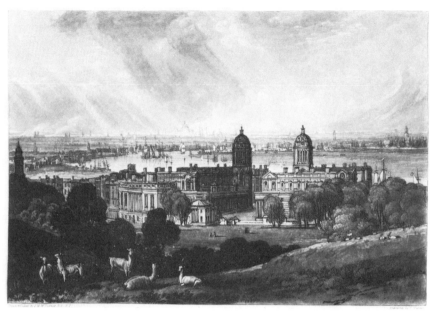

Turner's next major pictures dealing with such catastrophic subjects did not appear until 1810. The five years between *The Shipwreck* and both *The Fall of an Avalanche in the Grisons* (see Figure 6) and *The Wreck of a Transport Ship* (Fundaçao Calouste Gulbenkian, Lisbon, Portugal) marked a lull in his production of works devoted to nature's dramatic or violent aspects. With Europe closed for travel at this time, he returned to exploring the English countryside, creating more serenely poetic scenes such as *Sun rising through Vapour; Fishermen cleaning and selling Fish* of 1807 (National Gallery, London). He also painted one of his rare genre scenes, *A Country Blacksmith disputing upon the Price of Iron, and the Price charged to the Butcher for shoeing his Poney* (Tate Gallery), and a series of views along the Thames. He once again displayed patriotic pride in recent British naval history in the epic *The Battle of Trafalgar, as seen from the Mizen Starboard Shrouds of the Victory* completed in 1808 (Tate Gallery), which celebrated a glorious victory at the same time that it commemorated Admiral Nelson's tragic death.

The full range of Turner's subject matter became evident at this time through a project, the *Liber Studiorum*, he had begun in 1806.[8] In the seventeenth century, Claude Lorrain (1600-1682), a French artist that Turner admired, had made a series of drawings called the *Liber Veritatis*, documenting the compositions of all his completed paintings. Greatly admired in England, these drawings were engraved and published in 1777 by Richard Earlom (1743-1822), and these prints, in turn, inspired Turner's plan for his own set of mezzotints. The *Liber Studiorum*, which occupied him off and on until 1819, was designed to prove his artistic ingenuities and skills by demonstrating all of the different types of landscape in which he worked. His varied treatment of landscape subjects is indicated by the classifications listed on the cover: "Historical, Mountainous, Pastoral, Marine, Architectural." Each

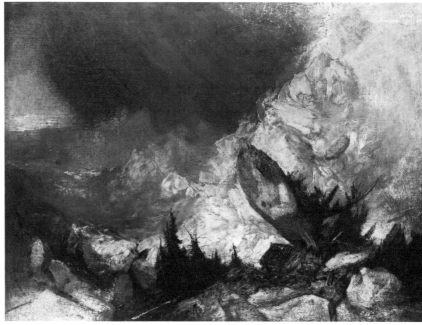

5 *The Woman and the Tambourine*. J. M. W. Turner. The Cleveland Museum of Art, CMA 19.124.

Figure 6. J. M. W. Turner. *The Fall of an Avalanche in the Grisons* (*Cottage Destroyed by an Avalanche*). Oil on canvas, 35-1/2 x 47-1/4 inches, exh. 1810. The Tate Gallery, 489.

print was labeled with initial letters corresponding to one of these categories. Included were biblical scenes—such as *The Fifth Plague of Egypt* [1]—views of the sea [2], the Alps [3], and London from Greenwich [4], along with poetic renderings of the English countryside and Italianate landscapes inspired by Claude Lorrain [5].

In 1810 Turner once again expressed with thundering force the hostility of nature to man in *The Fall of an Avalanche in the Grisons* (Figure 6). Inspired by a tragedy that occurred in 1808, but based on sketches made on his earlier visit to Switzerland in 1802, the oil depicts an Alpine cottage being crushed by a tremendous boulder.[9] Unusual among Turner's portrayals of natural catastrophe, and reflecting the facts of this particular incident, the composition includes no human figures. Turner leaves the horrible death of the cabin's inhabitants to the

viewer's imagination. The diminutive size of the trees and cottage reinforces the overwhelming power and scale of falling ice and rock,[10] and the thick, rugged handling of the pigment, applied with a palette knife, intensifies the appalling violence of the scene.[11] This visual pessimism is amplified by the verse Turner wrote to accompany this tragic scene:

> The downward sun a parting sadness gleams,
> Portentous lurid thro' the gathering storm;
> Thick drifting snow on snow,
> Till the vast weight bursts thro' the rocky barrier;
> Down at once, its pine clad forests,
> And towering glaciers fall, the work of ages
> Crashing through all! extinction follows,
> And the toil, the hope of man—o'erwhelms.[12]

Two years later another Alpine subject afforded further refinement of Turner's philosophy of nature. In *Snow Storm: Hannibal and his Army Crossing the Alps* (Figure 7), a mountain pass is the setting for an episode from ancient history. The painting's theme was reinforced by the poetic caption Turner published in the exhibition catalogue. In an extract from his ''epic'' poem, *Fallacies of Hope*, that artist ponders the dangers of false pride and disappointed ambition:

> Craft, treachery, and fraud—Salassian force
> Hung on the fainting rear: the Plunder seiz'd
> The victor and the captive—Saguntum's spoil,
> Alike become their prey; still the chief advanced,
> Look'd on the sun with hope;—low, broad and wan;
> While the fierce archer of the downward year
> Stains Italy's blanch'd barrier with storms.
> In vain each pass, ensanguin'd deep with dead,
> Or rocky fragments, wide destruction roll'd.
> Still on Campania's fertile plains—he thought
> But, the loud breeze sob'd ''Capua's joys beware!''[13]

In this gloomy oil, the Carthaginian army descends into Italy at the onset of the Second Punic War in 218 BC. History recounts that as they traveled through the Alpine pass fierce mountain tribesmen (the Salassians), ambushed the rear guard. Hannibal (not visible in Turner's picture), in the lead and unaware of the attack, pressed onward toward the sunlit plains of Italy, certain of victory. Eventually, as the poem implies, this army would contribute to its own defeat by resting in Capua rather than continuing to fight. The theme was a timely one. Turner may have intended an analogy between Hannibal's failure to take Rome and the possible fate of his modern counterpart, Napoleon. Prophetically, the painting was exhibited in 1812, the year of Napoleon's retreat from Moscow. If this was indeed Turner's purpose, the Hannibal picture effectively demonstrates the artist's penchant for allegory.

Equally important, the *Hannibal* canvas epitomizes Turner's method of creation, for nature's dramas often ignited his artistic imagination. In this painting Turner com-

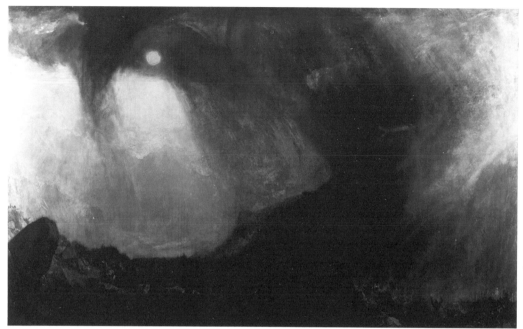

Figure 7. J. M. W. Turner. *Snow Storm: Hannibal and his Army Crossing the Alps*. Oil on canvas, 57-1/2 x 92-1/2 inches, exh. 1812. The Tate Gallery, 490.

bined an ancient historical event with observed natural phenomena. Walter Thornbury, the artist's first biographer, recounted an incident that occurred when Turner was staying in Yorkshire in 1810, at Farnley Hall, the home of his friend and patron, Walter Fawkes (1769-1825). According to Fawkes's son, Turner went outdoors one day to make sketches of a sudden thunderstorm, ''rolling and sweeping and shafting out its lightning over the Yorkshire hills. Presently the storm passed, and he finished. 'There! Hawkey,' said he. 'In two years you will see this again, and call it Hannibal Crossing the Alps.'''[14] If true, the incident proves how closely Turner's expressive art was tied to actual experience. His memory and imagination combine in the final picture, with its sweeping whirlwind vortex overwhelming the diminutive figures, not merely to produce a historical narrative but to interpret the event so that it becomes a universal

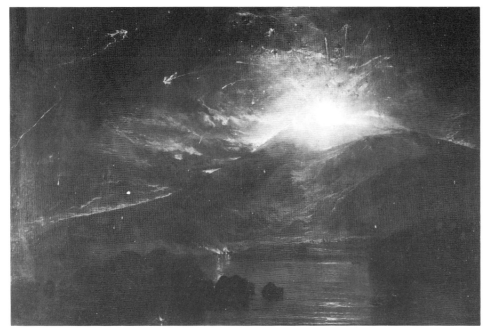

Figure 8. J. M. W. Turner. *The Eruption of the Souffrier Mountains, . . .* Oil on canvas, 31-1/4 x 41-1/4 inches, exh. 1815. England, University of Liverpool, 459.

Figure 9. J. M. W. Turner. *Shadrach, Meshach and Abednego in the Burning Fiery Furnace.* Oil on mahogany panel, 36-1/16 x 27-7/8 inches, exh. 1832. The Tate Gallery, 517.

statement of man's fragility in the presence of nature's ominous forces. Well received by the critics, *Snow Storm: Hannibal and his Army Crossing the Alps* helped to reinforce the artist's position as the premier landscapist of the day.

During the next several years Turner continued to explore a wide range of subjects. For example, his exhibited works of 1815, three years after *Hannibal*, include the history picture *Dido building Carthage* (National Gallery, London), which Turner always considered one of his most successful paintings, *Crossing the Brook* (Tate Gallery), and *The Eruption of the Souffrier Mountains* (Figure 8).[15] The first two again demonstrate Turner's admiration for Claude Lorrain.[16] The third continues his earlier interest in scenes of natural cataclysm. *The Eruption of the Souffrier Mountains*, depicting a spectacular volcano on the Caribbean island of St. Vincent, is one of the rare instances where Turner specifically used fire as a vehicle of expression before the 1830s. In this painting he once again captured the reality of a dramatic incident by suppressing detail and subordinating humanity to nature's fury. Man's presence is indicated only by small boats visible on the water in the obscure foreground and on the far shore. These boats both establish scale and reinforce man's insignificance in the face of the sublime horror of nature's unleashed energy and fire.[17]

By this time Turner's pictures were commanding substantial prices among collectors. Over the years he had acquired several important aristocratic patrons, some of whom also become close personal friends. Most notable were the already mentioned Walter Fawkes, who until his death in 1825 offered Turner companionship and enlightened interest, and George Wyndham (1751-1837), the third earl of Egremont, whose home, Petworth House in West Sussex, became a major element in Turner's work from the late 1820s and 1830s. Both men faithfully supported Turner's efforts even as others reacted adversely to his personal landscape style which focused increasingly on the effects of light and atmosphere. Since 1801 the artist's chief critic—Sir George Beaumont (1753-1827), an influential painter and collector—had

attacked Turner for his distinctive handling of paint and color and the apparent lack of formal organization in his composition. In October 1812 Beaumont was quoted as saying: "At his setting out He painted some pictures, 'The Fifth Plague of Egypt,' which gave great promise of His becoming an artist of high eminence, but He has fallen into a manner neither true nor consistent. . . . Much harm . . . has been done by endeavoring to make paintings in oil appear like watercolors, by which in attempting to give lightness and clearness the force of oil painting is lost."[18] There is some truth to Beaumont's observations, since Turner had indeed been adopting the light grounds and thin washes of the watercolor medium in order to achieve a special luminosity in his oils, but conservative critics were not prepared to change their opinions.

Despite such attacks, the artist enjoyed the support of the powerful Sir Thomas Lawrence (1769-1830), who was elected president of the Royal Academy in 1820. It was Lawrence who encouraged Turner's first visit to Italy in 1819, at the age of forty-four. Turner returned to England the following year with twenty-two sketchbooks containing mostly pencil drawings but also a number of watercolor studies made in the vicinity of Rome, Naples, and Venice. His memory of the dazzling sunlight and vivid color of Italy, especially that of Venice, became an increasingly important source of inspiration in his later years. More immediately, however, Rome and its classical grandeur inspired two large-scale pictures, *Rome Seen from the Vatican* of 1820 and *Forum Romanum* of 1826 (both Tate Gallery).

In 1825 Turner again returned to the Continent this time to visit Holland, Belgium, and Germany. As always he came home with numerous sketches, the subjects of which reappeared later in paintings and watercolors. In the meantime he also produced several series of watercolors depicting popular views of British architecture and picturesque scenery which were then engraved since such prints always sold well. The series, *Rivers of England*, was published between 1823 and 1825, while *Picturesque Views of England and Wales* extended over the next thirteen years (1825-1838).

As the years progressed Turner continued to paint in an increasingly summary manner and to explore an exceptionally broad range of subjects. After a second trip to Italy in 1828 his paintings became even more luminous and visionary, keeping him at the center of artistic controversy. Critics were ever more dismayed by the dazzling color of works such as *Ulysses deriding Polyphemus*, exhibited in 1829 (National Gallery, London), which the *Morning Herald* for May 5 described as "coloring run mad." The *Burning Fiery Furnace* (Figure 9), exhibited in 1832, provoked a similar response. The *Morning Post* of May 29 called it "a kind of phantasmagoric extravaganza. . . . in which the reds have prevailed," and which "ought itself to be put into the mouth of a fiery furnace." The picture was based on the biblical narrative from Daniel in which the three Jews, Shadrach, Meschach, and Abednego, were cast into a furnace for refusing to worship an idol set up by King Nebuchadnezzar. Miraculously, they were not harmed by the flames. Turner chose this subject in the course of a friendly rivalry with another painter, George Jones (1786-1869), who had told him of his intention to paint this theme. The motif of incandescent flame was certainly appropriate for Turner's style, and the resulting work displays the strong light and glowing colors of the paintings on fiery themes that Turner would produce in the 1830s.

Although notoriously secretive about his working methods, by the early 1830s Turner had established a practice of working in full view of his fellow artists, making final touches during the "varnishing days" preceding the opening of the summer exhibitions of the Royal Academy.[19] He often submitted unfinished canvases for exhibition, and after seeing where his works were to be hung, he then completed them—making changes to be sure they held their own—with a bravura display of painterly skill that amazed his colleagues. In 1835, for example, the Philadelphia version of the *Burning of the Houses of Parliament* was finished on varnishing day at the British Institution.[20] The same may have been true for the Cleveland version, shown later that year at the Royal Academy.

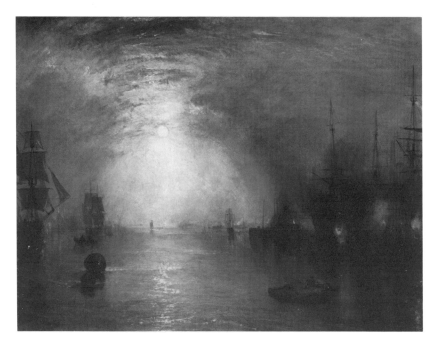
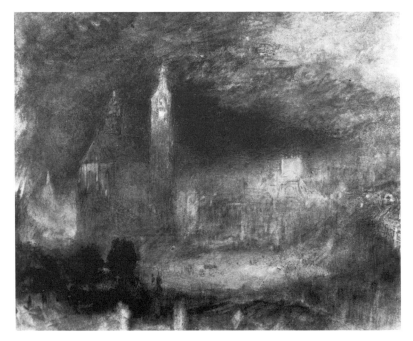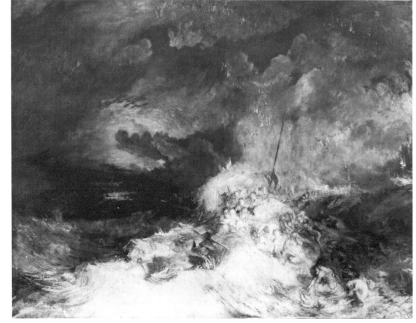

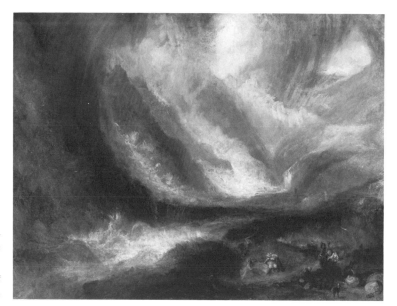

Far left: Figure 10. J. M. W. Turner. *Keelmen heaving in Coals by Night.* Oil on canvas, 36-1/4 x 48-1/4 inches, exh. 1835. Washington, D.C., National Gallery of Art, Widener Collection, 682.

Left: Figure 11. J. M. W. Turner. *Fire at Fenning's Wharf.* Watercolor and pencil, 11-3/8 x 17-1/4 inches, ca. 1836. England, University of Manchester, Whitworth Art Gallery, D.100.1892.

Figure 14. J. M. W. Turner. *Snow-storm, Avalanche and Inundation: a Scene in the Upper Part of Val d'Aousta, Piedmont.* Oil on canvas, 36 x 48-1/4 inches, exh. 1836. Courtesy of the Art Institute of Chicago, Frederick T. Haskell Collection, 1947.513.

Turner was to become ever more daring with paint and color. He explored the fire and water theme seen in the Parliament paintings in yet another picture exhibited at the Royal Academy in 1835—*Keelmen heaving in Coals by Night* (Figure 10). In succeeding years he produced several more works, both in watercolor and oil, in which fire played a prominent role. These included *Fire at Fenning's Wharf* and *A Conflagration, Lausanne* (Figures 11 and 12), of 1836. In his *A Fire at Sea* (Figure 13) of 1835 and *Stormy Sea with Blazing Wreck* of 1835-1840 (both Tate Gallery), Turner combined the drama of fiery destruction with his earlier interest in shipwrecks.

The artist returned to yet another of his earlier disaster themes with the work, *Snow Storm, Avalanche and Inundation—a Scene in the Upper Part of Val d'Aousta, Piedmont* (Figure 14), exhibited in 1837. Here he repeated the vortical composition used in the earlier *Snow Storm: Hannibal and his Army Crossing the Alps* (see Figure 7). And, as in the earlier *The Fall of an*

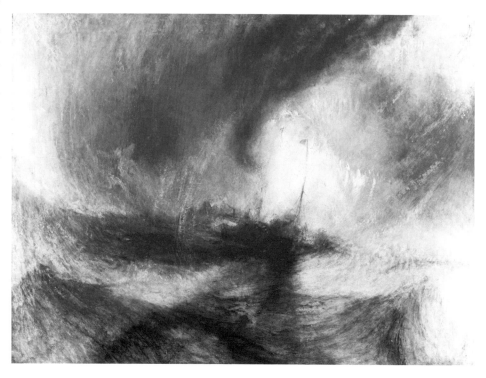

Far left: Figure 12. J. M. W. Turner. *A Conflagration, Lausanne.* Watercolor and gouache, 9-1/2 x 12 inches, ca. 1836. Whitworth Art Gallery, D.6.1912.

Left: Figure 13. J. M. W. Turner. *A Fire at Sea.* Oil on canvas, 67-1/2 x 86-3/4 inches, ca. 1835. The Tate Gallery, 558.

Figure 15. J. M. W. Turner. *Snow Storm—Steam-Boat off a Harbour's Mouth. . . .* Oil on canvas, 36 x 48 inches, exh. 1842. The Tate Gallery, 530.

Avalanche in the Grisons (see Figure 6), he subordinated detail to a tumultuous rush of paint, describing the swirling union of snow, clouds, and rushing water threatening to destroy the small figures in the right foreground.

In the 1840s Turner went even further in his quest for painterly freedom. In *Snow Storm—Steam-Boat off a Harbour's Mouth . . .* of 1842 (Figure 15), seen by many as the culmination of all Turner's meditations on the brute force of nature, a single boat—symbolic of man's destiny—is completely overwhelmed by the raw energy of snow, wind, and water.[21] The sweeping, circular movement of the composition gives the viewer a feeling of participation in the drama. Turner always maintained that this remarkably abstract picture emerged from the truthful immediacy of personal experience: he claimed he had had himself tied to the mast of the steamship *Ariel* so that he could fully experience the chaos and confusion of a stormy sea.[22]

Simultaneously, Turner continued painting his other favored subjects—historical and literary themes, Venetian scenes (returning to that city in 1833 and 1842), and topical events. Among the latter, strong patriotic feelings inspired by an event Turner had witnessed in the 1830s, are expressed in *The Fighting 'Temeraire,' tugged to her Last Berth to be broken up, 1838* (Figure 16)—a tribute to a warship having had a distinguished role in the Battle of Trafalgar. Representing the bygone age of sail, the great old ship in Turner's painting is being towed by a smoking tugboat, symbolic of the industrial age, up the Thames to a shipyard. The glowing sunset emphasizes the end of an era. Perceived as a nostalgic reminder of England's glorious past, this work was a great favorite not only with the public but also with most of Turner's critics. In 1843, soon after its exhibition, the artist's staunchest advocate, John Ruskin (1819-1900), published the first volume of his *Modern Painters.* The book has as its leitmotif Ruskin's belief that Turner was one of the greatest artists of all time.

Throughout his career, Turner had no official pupils even though he taught at the Royal Academy, willingly sharing his

Figure 16. J. M. W. Turner. *The Fighting 'Temeraire,' tugged to her Last Berth to be broken up, 1838*. Oil on canvas, 35-3/4 x 48 inches, exh. 1839. London, Reproduced by courtesy of the Trustees, The National Gallery, 524.

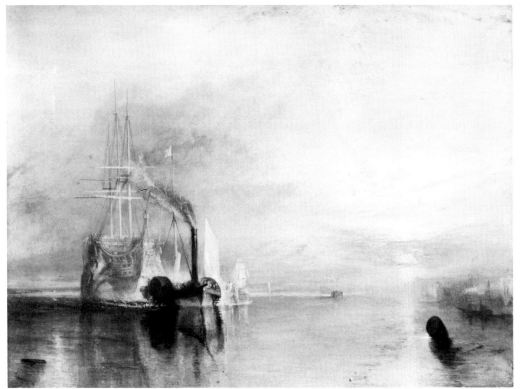

24

knowledge with younger artists, as well as presenting the formal perspective lectures. One of the younger artists, S. W. Parrott (1813-ca. 1878), captured a likeness of Turner painting on varnishing day (Figure 17). In this work Turner appears much as the authors Richard and Samuel Redgrave described him:

> In the last twenty years of his life . . . his short figure had become corpulent—his face . . . was unusually red, and a little inclined to blotches. . . . He generally wore . . . a black dress-coat, . . . the sleeves [of which] were mostly too long, coming down over his fat and not over-clean hands. He wore his hat while painting on the varnishing days. . . . This, together with his ruddy face, his rollicking eye, and his continuous, although, except to himself, unintelligible jokes, gave him the appearance of one of that now wholly extinct race—a long-stage coachman.[23]

Turner continued to exhibit his work until the year before his death and always maintained an interest in the activities of the Royal Academy. Although a controversial public figure within London's artistic circles, Turner was, in actuality, a rather private person preoccupied with his art. He never married but did father two illegitimate daughters. Fiercely independent, he sometimes even concealed his residence and assumed a false identity to avoid entanglements. During the final years of his life, he became a virtual recluse, taking a cottage in Chelsea and pretending to be a retired naval officer. He died there on December 19, 1851, at the age of seventy-six.

Over the years Turner had frequently revised his will, hoping to leave his unsold finished pictures to the British nation, to be housed in a permanent Turner gallery. His will also stipulated that his considerable fortune be used to fund a home for indigent artists. Although the contents of his studio at his death did eventually become the nation's property, years of litigation by distant relatives ultimately thwarted his philanthropic plans. The greatest concentration of Turner's work has accordingly remained in England.

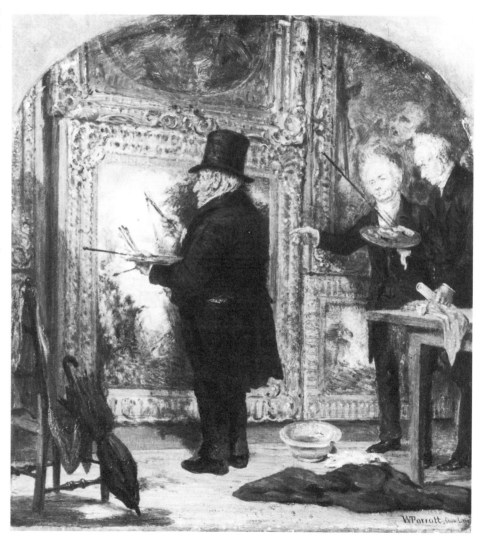

Figure 17. S. W. Parrott, British, 1813-ca. 1878. *Turner on Varnishing Day*. Oil on panel, 9-7/8 x 9 inches, ca. 1846. England, by permission of Sheffield City Art Galleries.

DREADFUL FIRE!

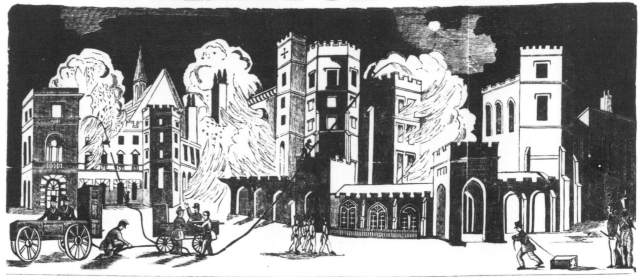

Figure 18. Broadside describing the Parliament fire, with woodcut illustration. Published by G. Drake. 22 x 16 inches. Westminster City Libraries, Archives Department, E133 (106).

And total destruction of both Houses of Parliament.

On Thursday evening, between six and seven o'Clock, a fire broke out in the House of Lords. The flames spread very rapidly, and great alarm immediately prevailed. Detachments of police soon arrived from the different station-houses, and the engines from the different fire-stations were brought to the spot with the utmost expedition. Immense crowds of people at the same time assembled, and filled up the different avenues to the building. At first there was a deficiency of water; but a supply was soon procured, and the firemen made the utmost exertions to get the fire under; but it had already gained such strength, that their efforts appeared to have little effect. Unfortunately, too, there was a considerable wind from the south-west. In a very short time after the commencement of the fire, strong detachments of the first regiment of Grenadier Guards and of the Coldstream Guards marched to the spot, and with the assistance of the police, kept an open space before the building, so as to allow the firemen to work without impediment. Lord Melbourne soon arrived, along with several other noblemen; and Mr. Gregorie, the magistrate of Queen-square, sent off the whole of the officers

out of the different offices, &c. where they were deposited, and put into all sorts of vehicles— hackney-coaches, cabs, waggons, &c. which were put in requisition for their conveyance to places of safety. Many of them were placed in private houses opposite; but the greater part were conveyed to the various Government offices. In performing this duty many of the firemen incurred great danger, but nothing could exceed their zeal and disregard to personal risk.

As the fire extended itself in the direction of Westminster Hall, the utmost efforts were made (and happily with success) to preserve that venerable edifice.

While the turret in the western corner was in flames, Lord Frederick Fitzclarence, with several policemen and soldiers was in the uppermost room. They were not, at first, aware of their danger; but as their perilous state; was discovered by persons without, a fireman's ladder, which is formed of parts that slide on each other, was instantly put up to the top window and they descended, Lord Frederick being the last who got upon the ladder. At this time a

of Commons fell in, three firemen and one of the Life Guards were buried in the ruins; but they were got out alive. Many persons were seriously injured; but we have not heard of any loss of life.

At eleven o'clock, an express was received by Mr. Cooper, Secretary to the Record Board, at his house in the country. He arrived at twelve, and found that, in an early part of the evening, nearly the whole of the extremely valuable records of the Augmentation Office, upon the repairing and arrangement of which so many thousand pounds have been spent within the last four years, had been thrown out of the windows, and removed in various ways—some to the King's Mews, but the greater part to St. Margaret's church. A vast number of the most ancient, in the course of this operation, unfortunately fell out of the boxes and bags, and were scattered about the street. A number of soldiers, under the direction of Mr. Cooper, were employed, during the whole of the night, in collecting these; and large numbers were recovered, saturated with water and very much defaced.

Tower, at the south end of the building, totally destroyed. The Painted Chamber, totally destroyed. The north end of the Royal Gallery abutting on the Painted Chamber destroyed from the door leading into the Painted Chamber, as far as the first compartment of columns. The Library and the adjoining rooms, which are now undergoing alterations, as well as the Parliament Offices and the Offices of the Lord Great Chamberlain, together with the Committee Rooms, Housekeeper's Apartments, &c., in this part of the building are saved.

House of Commons. The House, Libraries, Committee Rooms, Housekeeper's Apartments, &c. are totally destroyed (excepting the Committee Rooms Nos. 11, 12, 13 and 14, which are capable of being repaired.) The official residence of Mr. Ley (Clerk of the House); this building is totally destroyed. The official residence of the Speaker; the State dining room under the House of Commons is much damaged, but capable of restoration. All the rooms of the oriel window to the south side of the House of Commons are destroyed. The Levee Rooms and other parts of the building, together with the public galleries

PART TWO Dreadful Fire!

The destruction of the Houses of Parliament by fire in October 1834 was a devastating loss to the British nation. The complex of buildings on the banks of the Thames at Westminster, as shown in John Gendall's accomplished watercolor of 1818 (Figure 19), had enormous historical significance.[1] For centuries it had been the site not only of the Houses of Parliament but also the London residence of the sovereign and the principal courts of justice.

Canute the Great, a Danish King who ruled England by right of conquest from 1017 to 1035, was the first monarch to make his home at Westminster. His palace burned, however, just before the Saxon king, Edward the Confessor, took the throne in 1042. Edward then began rebuilding the palace, which was completed by the time his successor, William the Conqueror, won the crown in 1066. Other sovereigns added to the buildings which were once again ravaged by fire in 1512, during the reign of Henry VIII. In 1529 this monarch abandoned the Palace of Westminster for York Hall, renaming it Whitehall, and none of the succeeding monarchs used the Palace of Westminster as a residence.

The earliest English Parliaments began meeting at Westminster in the thirteenth century under Henry III. Then in 1295 Edward I convened the assembly of clergymen, nobles, and burghers that became known as the ''Model Parliament.'' These three groups continued to meet together as one body until 1377 when, under Edward II, Parliament was divided into two Houses—one for the Commons and one for the Lords. Although the House of Commons initially met in the Chapter House of Westminster Abbey, somewhere between 1548 and 1550 Edward VI granted use of the four-

teenth-century royal chapel of St. Stephen (Figure 20), where members assembled until the fire of 1834. This Gothic-style chapel had been completed by Edward III on the ruins of the original St. Stephen's Chapel, built two hundred years earlier

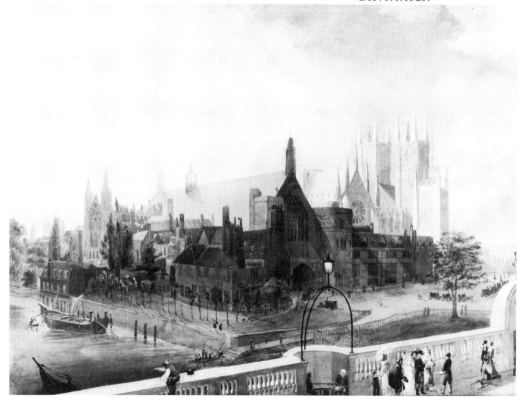

Figure 19. John Gendall, British, 1790-1865. *View of Westminster Hall and Abbey from the Bridge*. Watercolor heightened with white bodycolor over pencil, 14-1/16 x 18-3/4 inches, 1818. Yale Center for British Art, Paul Mellon Collection, B1975.4.1923.

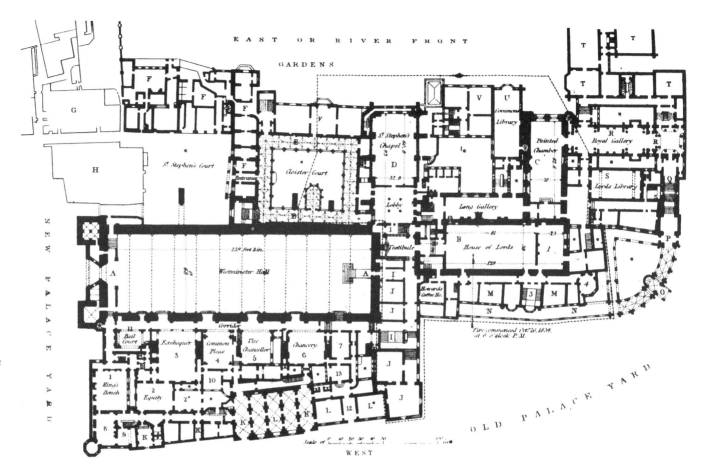

Figure 20. Robert William Billings, British, 1815-1874. *Ground Plan of the Parliamentary Buildings, Ancient Palace, and Adjoining Law Courts.* After Brayley and Britton, *Westminster*, pl. II.

A general ground plan of the entire site of the Palace of Westminster and the Parliamentary Buildings, showing the relative positions, arrangements, sizes, etc., of the numerous offices and apartments connected with the two Houses of Parliament and the Law Courts, as they appeared prior to the fire in October 1834. Dotted lines indicate the extent of the fire.

The oldest parts, marked darker than the rest, are: **A.A.** *Westminster Hall* **B.** The *Old Court of Request,* afterwards the *House of Lords,* and made the House of Commons after the fire (**1.** The King's Robing Room. **2.** Lobby. **3.** Stairs. **4.** Lord Chancellor's Room.) **C.** The *Painted Chamber,* made the House of Lords after the fire. **D.** *St. Stephen's Chapel,* afterwards the *House of Commons,* until the fire.

The rest of the complex includes: **E.E.** The *Cloister* attached to St. Stephen's Chapel. **F.F.F.** The *Speaker's House.* **G.** Part of the offices of the Exchequer. **H.** Houses of John Rickman, Esq., Clerk Assistant of the House of Commons, and William Godwin, Esq., Author of the "Life of Chaucer," etc. **I.I.** Stairs to the House of Commons. **J.J.** *Committee Rooms.* **K.K.** The Judges' Entrance to the respective *Law Courts,* which are numbered on the plan as follows: **1.** Court of King's Bench, **2.** Court of Equity. **3.** Court of Exchequer. **4.** Court of Common Pleas. **5.** Vice Chancellor's Court. **6.** High Court of Chancery. **7.** Lord Chancellor's retiring room. **8.** Judges' retiring room. **9.** Attendants' waiting room. **10.** Barons' retiring room. **11.** Bail Court. **12.** The Lord Chancellor's entrance. **L.L.** Grand Inquest Jury Rooms. **L.*** Library of the Masters in Chancery. **M.M.** *Committee Rooms* to the House of Lords. **N.N.** *Arcade* to the House of Lords. **O.** The *King's Entrance Porch.* **P.** Entrance to the *King's Staircase,* which is at Q. **R.R.** The *Royal Gallery.* **S.** *Library of the House of Lords.* **T.T.T.** Parliament Offices. **U.** *Library of the House of Commons.* **V.** *House of the Clerk of the House of Commons.* **W.** *Long Gallery.*
****** Open Courts.

in the twelfth century by King Stephen and dedicated to St. Stephen.[2] In an effort during the late seventeenth century to transform the chapel into a secular assembly hall, Sir Christopher Wren (1632-1723) installed a false ceiling below the Gothic vault, covered the frescoed walls with oak paneling, and removed the stained glass. Other changes were made in 1707 and 1800 after the unions with Scotland and Ireland when seating had to be provided for added members. Many of the greatest events in British political history took place in St. Stephen's Chapel. They include the struggle against the Stuarts for constitutional government, pleas for a more liberal treatment of the American colonies by such members of Parliament as Edmund Burke, enactment of the abolition of slavery bills, and the passage of the Reform Bill of 1832.

The House of Lords met in a chamber at the south end of the palace until 1800 when it was relocated in the old Court of Requests.[3] Like the House of Commons, this was an oblong room with rows of benches rising from floor to ceiling. A great set of tapestries, depicting scenes from the defeat of the Spanish Armada in 1588 and separated by oak frames, adorned the walls.[4] The royal throne, used by all the sovereigns of England from 1550 to 1834, stood at the top of the chamber, beneath an elaborate canopy.

The old Palace of Westminster did not lack elaborate staterooms. The ceremonies heralding the opening and closing of Parliamentary sessions took place in the Painted Chamber, the walls of which were decorated with elaborate biblical battle scenes painted during the mid-thirteenth century. Here in 1649 Oliver Cromwell signed the warrant for the execution of Charles I on charges of treason. Later the Painted Chamber became simply a conference room where members of both Houses met to devise compromises on disputed legislation.

The finest feature of the old Parliamentary complex was Westminster Hall, an enormous structure built during the eleventh century by William Rufus (1087-1100). Under Richard II in the fourteenth century it was enlarged and the flat roof and semicircular-topped windows of the original Norman structure were remodeled in the Gothic style. Its magnif-

icent oak-beamed roof had horizontal wooden supports carved in the shape of angels.[5] Over the years Westminster Hall endured many repairs and alterations; in fact, at the time of the 1834 fire the windows and interior stonework, including the floor, had only recently been renovated and restored. In its early days the stately room was the scene of much pageantry and feasting especially during coronations. It also served as the great public audience chamber of the sovereign. More significantly, however, it functioned as a judicial center. From the thirteenth century until 1884 the chief English courts of law—the Courts of Chancery and King's Bench—assembled at Westminster Hall, at first within the hall itself and later, after 1820-24, in buildings constructed on its west side under the direction of the prominent London architect, Sir John Soane (1753-1837). Many memorable trials took place in Westminster Hall. The trial of Charles I for treason in January 1649 is especially noteworthy, along with the eighteenth-century trial of the Duchess of Kingston for bigamy. The last public trial conducted in the hall before the fire was that of Lord Melville (1806) for corruption while serving in the Naval Administration. This venerable chamber witnessed other historic episodes, both political victories and defeats. In 1327 Edward II abdicated there, and in 1399 Richard II was ironically deposed in the hall he had personally had renovated. Here also over two hundred years later, Oliver Cromwell declared himself Lord Protector of England. Sir Thomas More (d. 1535), Guy Fawkes (d. 1606), and Thomas Wentworth, Earl of Strafford (d. 1641) were each condemned to death in Westminster Hall.[6]

Although the Palace of Westminster symbolized to all Englishmen their historical legacy, as it stood in 1834 it was not noted for its architectural beauty. Its numerous restorations and periodic enlargements had produced an eclectic architectural complex, both confusing and inconvenient. By the early nineteenth century the palace had developed into "a labyrinth of intricately connected courts, residences, state rooms, office accommodations, libraries, chapels, armament rooms,

law courts, coffee houses, kitchens, and so on, linked by a multitude of narrow, gloomy and unhealthy passages, much of it built of brick and stone but a great deal made of timber covered with lath and plaster."[7] According to John Wilson Croker (1780-1857), who had been a Member of Parliament for twenty-five years, there was "no proper access for members to the Houses of Parliament." He complained in 1833 that "A member must pass every day of his life up a series of narrow, dark and tortuous passages, where any individual who wishes to insult him may have the certain and easy opportunity of doing so."[8]

General apprehensions about the physical well-being of the palace complex, and especially the risk of fire, were frequently voiced. During the 1820s Sir John Soane was responsible for building new offices and committee rooms and various other attempts at easing the discomforts of the Members. In 1828 he observed, "The exterior of these old buildings . . . as well as the interior, is constructed chiefly with timber covered with plaster." He then went on to ask, with disconcerting foresight, "In such an extensive assemblage of combustible materials, should a fire happen, what would become of the Painted Chamber, the House of Commons and Westminster Hall? Where would the progress of the fire be arrested?"[9]

All these problems were taken up in 1831 by a parliamentary select committee which, after investigating ways to make the House of Commons "more commodious and less unwholesome,"[10] arrived at the same conclusion that members of the House had reached nearly a century earlier: a new building was needed. The matter was further studied by a second committee in 1833 which also concluded that the existing House of Commons was beyond repair and rebuilding imperative.[11] At the same time, however, the committee called for the preservation and restoration of St. Stephen's Chapel—the Old House of Commons—and suggested its possible usefulness as a library, lobby, or chapel for the new House.[12]

Fifteen architects were then consulted in an effort to determine not only the most appropriate site for the new House, but also its size, architectural style, and other considerations such as ventilation, heating, acoustics, and the provision of galleries for reporters and the public.[13] This last requirement was particularly important since "the House in session was one of the sights of London."[14] But in the following year, 1834, more pressing matters overshadowed the project. The depressed state of the national economy, in particular, absorbed Parliament's interest, and the need for a new Bankruptcy Court at Westminster received more immediate attention. The Treasury ordered the Board of Works to provide temporary accommodations for the Court by refurbishing part of the Exchequer Offices, including the office known as the tally-room.[15]

Exchequer accounts had formerly been kept on notched sticks, usually hazelwood, called "tallies." From the twelfth to the nineteenth century the tally was a recognized form of receipt for payments into the English Royal Treasury. Following a strict system of rules, tally sticks were notched to show the amount paid and then split lengthwise through the notches so that both parties involved in a transaction would have a record. The larger piece, called the stock, belonged to the payer; the smaller piece, the foil, remained with the Exchequer.[16]

Although the wooden tally system was abolished in 1826, the Exchequer's store of foils was not disposed of for another eight years. Previously they had been destroyed at more frequent intervals by simply using them as fuel in the fireplace of the tally-room. But by this time almost two cart loads had accumulated—too many for the fireplace. So it was decided by Alexander Milne, a commissioner of woods and forests, and John Phipps, assistant surveyor of works and buildings, to burn the tallies outdoors, in the Exchequer yard. Since the wood was very dry, this procedure would take only a couple of hours. Phipps gave the task to Richard Weobley, clerk of the works, who objected that such a bonfire would alarm the neighborhood and attract interference from the police. Instead Weobley suggested using the stoves of the House of Lords. Apparently Phipps approved Weobley's proposal without communicating with Milne. Later he explained that

he thought the furnaces were safe and considered Weobley a careful man, who would see that the tallies were burned in small quantities, although he never specifically instructed him to do so.[17]

On the evening of October 15, Weobley employed two laborers from the Board of Works, Joshua Cross and Patrick Furlong, to bring the tallies from the Exchequer to the House of Lords.[18] Returning at half past six the following morning, Thursday, October 16, they began burning them. Apparently Weobley cautioned them to be careful, for both men later stated that they had followed his directions to put only a handful of tallies into the furnace at a time, dampening them occasionally with water and never adding more until the previous sticks were nearly consumed.[19] Weobley himself checked their progress several times during the day and never questioned the safety of their enterprise.

It would seem, however, that during the intervals between Weobley's visits, the workmen did not follow his orders. Richard Reynolds, a firelighter who attended to the furnaces when the House of Lords was in session, claimed he saw Cross "laying (the tallies) in as fast as he could into the flues," about five or six handfuls at a time, creating what he called an "astonishing blaze." When Reynolds commented on the rapidity of the burning, Cross made no reply.[20]

Further evidence of impending disaster came from Mrs. Wright, housekeeper of the House of Lords. She claimed to have noticed smoke and the smell of burning wood in the House of Lords that morning at about ten o'clock. After discovering the cause, she spoke directly to Cross who informed her of his orders and assured her there was no danger. She also claimed to have sent him several more cautionary messages during the course of the day. Another witness, John Snell, a tourist visiting from the country, testified that about four o'clock he and a companion, a Mr. Shuter, were let into the House of Lords by Mrs. Wright. Mr. Snell said that once inside the chamber he felt a great deal of heat through the floor and was "much grieved that there was so much smoke in the House I could not see the tapestry, and I went over to put up my hand to convince myself that it was tapestry, but I do not think I saw above a foot square when I was near to it."[21] Evidently Mrs. Wright wanted the visitors to have a favorable impression of the House and attempted to divert their attention. By this time it was noticed that the temperature in the House of Lords had also climbed to sixty degrees.[22] According to Mrs. Wright's later testimony, she sent yet another word of caution to the two workmen. Nevertheless she proceeded to lock up the House of Lords at five o'clock without reporting the situation to higher authorities. Cross and Furlong claimed to have also left by five o'clock. Shortly after six o'clock the building caught fire and the battle to save Westminster Palace began.

Within half-an-hour after the alarm sounded, several companies of firefighters, police, and soldiers appeared on the scene. By this time, the fire was large enough for one observer to note that "a brilliant glare of ruddy light in the horizon . . . indicated that a conflagration of no ordinary character had somewhere broken out."[23] The *Times* reported that the flames "increasing, and mounting higher and higher, attracted the attention not only of the passengers in the streets, but if we may judge from the thousands of persons who in a few minutes were seen hurrying to Westminster, of the vast majority of the inhabitants of the metropolis."[24]

The flames spread rapidly, so that by seven o'clock the entire House of Lords was a mass of fire. About half past seven part of the roof fell in. Although originally the wind had been blowing almost directly from south to north, by about eight o'clock its direction shifted towards the northeast, blowing the flames onto the House of Commons which was quickly engulfed because of its largely timber construction (Figure 21). Despite the efforts of the firemen the Commons's roof "fell in with a tremendous crash, accompanied with an immense volume of flame and smoke, and emitting in every direction millions of sparks and flakes of fire. This appearance, combined with the sound . . . induced the assembled multitude to believe that an explosion of gunpowder had taken place"[25] (Figure 22).

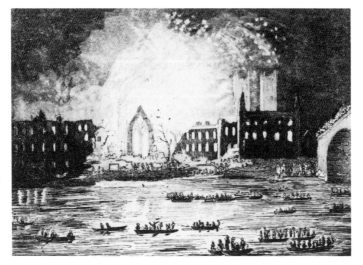

Figure 21. *Houses of Parliament Destroyed by Fire, October 16, 1834.* Engraving, 3-3/8 x 3 inches. Westminster City Libraries, Archives Department, E133 (35).

Figure 22. T. Picken, British, 1815-1870. *The Destruction of both Houses of Parliament, as seen from the Surrey-side, on the Night of the 16th Oct. 1834.* Lithograph, 7-1/4 x 5-1/8 inches. Westminster City Libraries, Archives Department, Box 57 No. 7b.

By eight o'clock, the safety of Westminster Hall had become a major concern, for its south end was completely surrounded by burning structures. The *Times* reporter observed, "it appeared as if nothing could save Westminster Hall from the fury of the flames. There was an immense pillar of bright clear fire springing up behind it, and a cloud of white, yet dazzling smoke, careering above it, through which, as it was parted by the wind, you could occasionally perceive the lantern and pinnacles by which the building is ornamented. At the same time a shower of fiery particles appeared to be falling upon it with such increasing rapidity as to render it miraculous that the roof did not burst out into one general blaze."[26] The prospect of losing this stately hall engendered

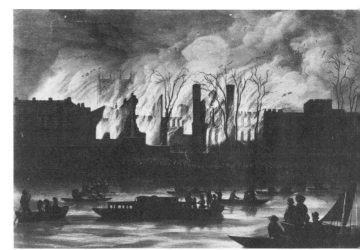

Figure 23. J. Hitchings, British, active ca. 1834. *View of the Conflagration of the Houses of Lords and Commons, As it appeared on the Night of Thursday October 16th 1834.* Colored lithograph, 11-3/4 x 7-7/8 inches. Westminster City Libraries, Archives Department, Box 57 No. 11a.

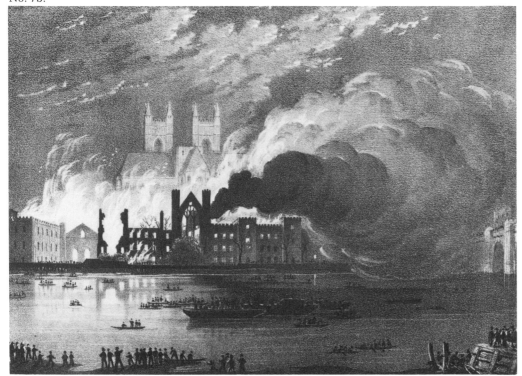

great anxiety among the watching throng, a feeling which was summed up by the correspondent for *Gentleman's Magazine*: "I felt as if a link would be burst asunder in my national existence, and that the history of my native land was about to become, by the loss of this silent but existing witness, a dream of dimly shadowed actors and events."[27] Attempting to halt the spread of the flames, several fire engines were moved into the hall to hose down its interior with enormous quantities of water, meanwhile other fire engines saturated its exterior and roof. Fortunately, the wind also cooperated, blowing the flames away from the roof and out over the river. Eventually this historic structure was saved.

The buildings lying along the river east of Westminster Hall were not as fortunate. Fanned by the wind, the blaze quickly spread with flames shooting furiously out of nearly every window of the complex, from the Parliament offices at the south end to the Speaker's House at the north (Figure 23). Bystanders were "so struck with the grandeur of the sight that they involuntarily . . . clapped their hands, as though they had been present at the closing scene of some dramatic spectacle, when all that the pencil and pyrotechnic skill can affect is put into action, to produce a striking coup d'oeil."[28] And, as many of the illustrators later revealed, "every branch and fibre of the trees which are in front of the House of Commons became clearly defined in the overpowering brilliance of the conflagration"[29] (Figures 24-27).

The Fusilier Guards were stationed in the Speaker's garden to control the spectators standing in the mud along the strand. Meanwhile teams of both civilians and soldiers began removing valuable books, papers, and furniture from the sections of the buildings they dared enter. All salvaged property was thrown out of the windows to parties stationed below and then taken to either the Speaker's garden, St. Margaret's Church (which had been opened for that purpose), or to the State Paper Office on Downing Street. More soldiers arrived about nine o'clock. Along with the police, they also attempted to restrain the dense crowd and to prevent looting. A *Times* correspondent noted "vast gangs of the light-fingered gentry

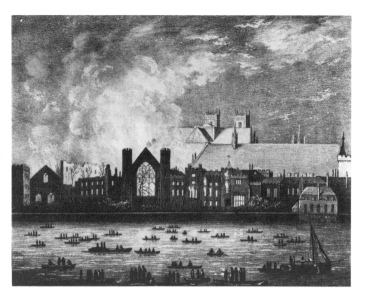

Figure 24. *A View of the Fire, from the River*. Lithograph, 10 x 7-3/4 inches. Westminster City Libraries, Archives Department, Box 57 No. 3a.

Figure 25. Thomas Musgrave Joy, British, 1812-1866, and C. Simpson. *View of the Destruction of Both Houses of Parliament*. Colored lithograph, 12-3/8 x 9 inches. Westminster City Libraries, Archives Department, Box 57 No. 1.

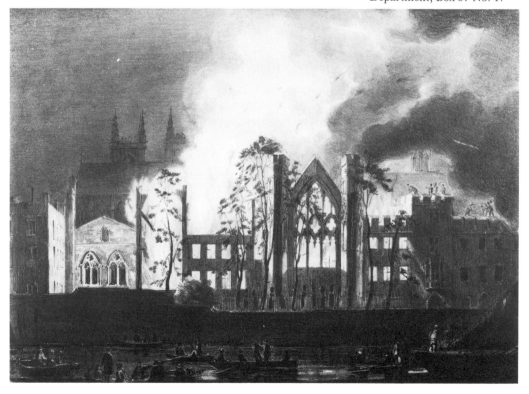

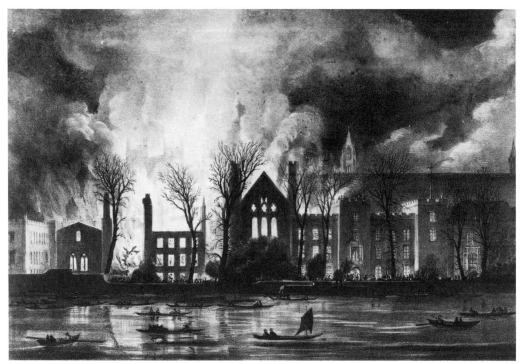

Figure 26. *Destruction by Fire, of Both Houses of Parliament. On Thursday Night, 16th Oct. 1834.* Colored lithograph, 11-3/4 x 7-7/8 inches. Westminster City Libraries, Archives Department, Box 57 No. 14.

Figure 27. Thomas Mann Baynes, British, 1794-1852/54. *The Destruction of Both Houses of Parliament by Fire. Oct: 16, 1834.* Colored lithograph, 12-5/8 x 8-3/4 inches. Westminster City Libraries, Archives Department, Box 57 No. 2a.

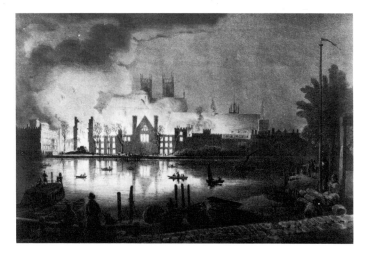

. . . who doubtless reaped a rich harvest."[30] A number of distinguished government officials, including Lord Melbourne, Lord Hill, Sir John Cam Hobhouse, and Lord Duncannon, actively aided the firemen.[31]

By eleven o'clock the fire's worst damage had been done. The roofs of Mr. Ley's house, the House of Commons, and the Speaker's House had collapsed, while the tower containing the Commons Library (located between the Painted Chamber and Mr. Ley's house) was "a mere shell, illuminated, however, from its base to its summit in the most bright and glowing tints of flame." Shortly after twelve o'clock the library tower tumbled down with an enormous crash of smoke and flame. The *Times* reporter grimly noted, "As soon as this smoke cleared away, the destructive ravages of the fire became more evident. Through the vista of flaming walls you beheld the Abbey frowning in melancholy pride over its defaced and shattered neighbours."[32]

The Painted Chamber and the library of the House of Lords had been completely destroyed by midnight. The House of Lords was also nearly gone, most of its exterior walls having fallen an hour earlier. Once again, the splintering of wood and shattering of glass sounded like gunfire. A dramatic lithograph by Gauci (Figure 28) depicts the fire from the west, possibly after some of the roofs and ceilings had given way and the numerous offices and committee rooms fronting the House of Lords and facing both Abingdon Street and Old Palace Yard were completely engulfed by the raging flames. At one o'clock the view from Westminster Bridge and the river was still quite spectacular, the whole range of gutted buildings burning furiously as one body of flame. A floating fire engine finally arrived about half past one (see Figure 47). The fire had broken out when the tide was at its lowest ebb, so the shallowness of the water had prevented the steamer from towing the apparatus all the way up the Thames from Rotherhithe to Westminster. Although arriving too late to save any of the burning buildings, the floating engine pumped enough water to confine the flames within the devastated structures. Nine hours after the fire began, it had been sub-

dued and controlled enough that apprehensions of further danger had subsided and the crowd had largely dispersed. By five o'clock the next morning only smoldering embers remained so the firefighters could rest after their long night's work. Only ten of them required hospitalization although many suffered minor injuries. Numerous stories circulated, praising those who had distinguished themselves in fighting the disastrous blaze.[33]

The next day the extent of the damage at Westminster was fully revealed. The final tally was published in the *Times* of October 18. In summary, the Painted Chamber, the whole of the House of Lords and Commons and the Commons Library, the official residence of Mr. Ley (clerk of the Commons), part of the Speaker's house, a number of committee rooms, and the housekeeper's apartments were all destroyed. Heavy damage was reported to the state drawing rooms beneath the House of Commons, the public galleries, and part of the cloister court adjacent to the Commons. Fortunately, the King's Entrance from Abingdon Street, the grand staircase, the Royal Gallery, the Law Courts, and most importantly, Westminster Hall were preserved.

Efforts to clear the site began immediately with barricades erected against the great crowds of curious spectators, among them numerous artists sketching the ravaged buildings.[34] The *Times* gloomily noted, however, that there was "nothing striking, nothing picturesque, in the appearance of the ruins. The devastation was too general and complete to present to the eye of the spectator any of those extraordinary combinations of shattered walls and tottering roofs which sometimes reconcile us by their terrible beauty to the very destruction which has created them."[35] This opinion notwithstanding, on November 2 the *Times* published three vivid pairs of "before and after" pictures of Westminster Palace (Figure 29). Along with the illustrations in Brayley and Britton's *Westminster* and other views made by artists on the site, they record with dramatic intensity the toll taken by the flames.

Robert William Billings's engraving (Figure 30), for example, shows Old Palace Yard with the western wall of the House of Lords at the right.[36] At the foot of the wall are the ruins of the Lords' committee rooms and part of the arcade that formerly fronted the yard providing entrance to the House of Lords. At the left is the structure that housed the Commons' committee rooms. The gable and pinnacle of Westminster Hall are visible in the background. A broader view of the yard is presented in a colored lithograph published by J. Douglass (Figure 31). The relatively unharmed structures at the southernmost end of the Palace complex, including the King's Entrance Porch, are visible at the right of the composition. Thomas Clark recorded a view of the gutted Long Gallery (which lay parallel to the House of Lords on its east side) looking north toward St. Stephen's Chapel, with the House of Lords to the left (Figure 32). Two workmen clear rubble from the cellars.[37] Another melancholy view by Billings of the south and west sides of the cloister adjacent to the House of

Figure 28. M. Gauci, British, active 1810-1846. *The Destruction by Fire of the Houses of Parliament. On Thursday Night Oct. 16th 1834.* Lithograph, 10-3/4 x 6-5/8 inches. Westminster City Libraries, Archives Department, Box 57 No. 13b.

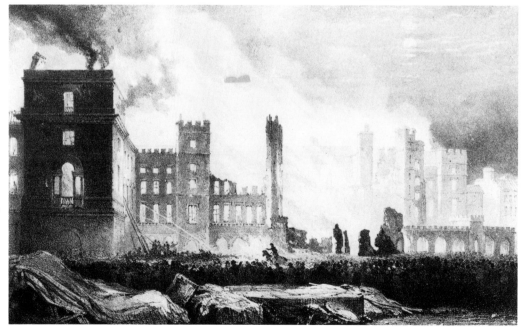

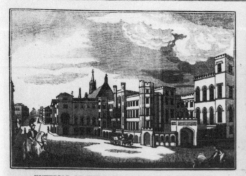

EXTERIOR OF THE LATE HOUSES OF PARLIAMENT.
TAKEN FROM PALACE-YARD.

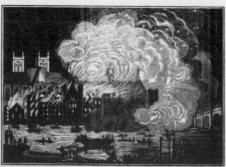

VIEW OF THE FIRE.
TAKEN FROM THE SURREY SIDE OF THE RIVER, ABOVE WESTMINSTER BRIDGE—OCTOBER 16, 1834.

INTERIOR OF THE HOUSE OF LORDS.

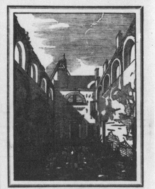

RUINS OF THE HOUSE OF LORDS.

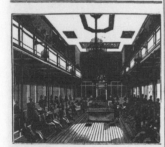

INTERIOR OF THE HOUSE OF COMMONS.

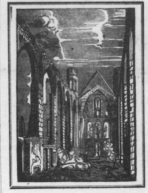

RUINS OF THE HOUSE OF COMMONS.

Figure 29. Illustrated Supplement to the Sunday *Times*, November 2, 1834, 23 x 16-1/2 inches. Westminster City Libraries, Archives Department, E133 (108).

Right: Figure 30. Robert William Billings, British, 1815-1874. *Ruins of the House of Lords, &c.* After Brayley and Britton, *Westminster*, pl. XXXVII.

Far right: Figure 31. *The Ruins of Both Houses of Parliament. Taken the Morning after the Fire.* Colored lithograph, 12 x 18 inches, published by J. Douglass. Westminster City Libraries, Archives Department, Box 57 No. 8d.

Commons (Figure 33) shows the two-story courtyard filled with water and, at the upper left, the still-smoking remains of St. Stephen's Chapel. The double oratory and a single buttress occupy the center, while part of the roof of the preserved Westminster Hall can be seen at the upper right. The amount of rubble produced by such a catastrophe obviously inspired Billings's view of the Speaker's Gallery on the upper level of the Cloister's west side (Figure 34). Here a workman stands knee-deep in debris with charred roof timbers protruding over the wall at the upper left and a section of flying buttress, darkened by the fire, looms in the background above the remains of a wood and plaster wall.

The ruined Palace of Westminster, as seen from the river, was recorded in a painting attributed to David Roberts (Figure 35).[38] Here the smoldering structures can be seen, from the blackened Parliament Offices at the left to the Speaker's Residence at the right. Figures standing on the roof and climbing a ladder to a lower window are faintly visible at the right of the composition. Westminster Abbey's roof and twin towers (at the left) along with the roof and pinnacles of Westminster Hall (to the right) form a shadowy backdrop through

Right: Figure 33. Robert William Billings. *Cloister Court, St. Stephen's Chapel.* After Brayley and Britton, *Westminster*, pl. XXV.

Far right: Figure 32. Thomas Clark, British, active ca. 1834-36. *Long Gallery, Looking North.* After Brayley and Britton, *Westminster*, pl. XXXIII.

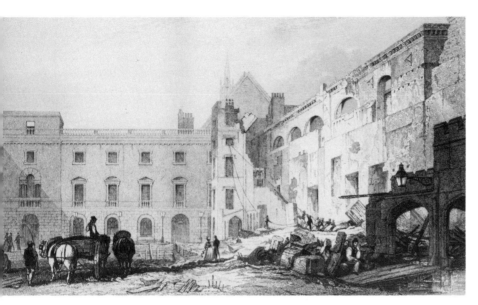

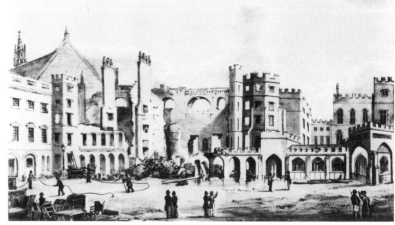

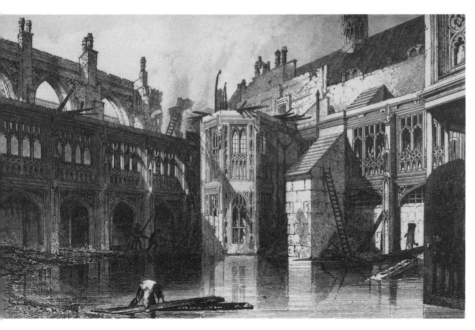

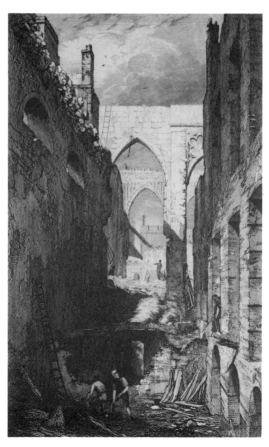

the smoky haze. In the foreground the river is cluttered with boatloads of curious spectators, including two artists sketching at the lower left.

Yet another Billings engraving (Figure 36) documents the skeletal structure of St. Stephen's Chapel, bathed in light, while the desolate hulk of the Painted Chamber lies in shadow. By January 1835, when this view was made, workmen had cleared the space between the two buildings where the Commons Library and Mr. Ley's house had formerly stood.

The quantity of artistic illustrations inspired by the great fire only partly reflects the public response to the disaster, for

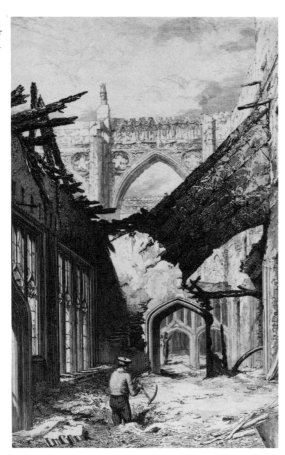

Figure 34. Robert William Billings. *Upper Cloister, Part of St. Stephen's Chapel, &c.* After Brayley and Britton, *Westminster*, pl. xxx.

in addition to the outcry over the loss of the buildings considerable speculation arose as to the initial cause of the fire. The *Times* of October 18 reported that "it was stated more than once, that it was the work of an incendiary, and persons even mentioned the names of public functionaries who had discovered in the Speaker's Garden, while the conflagration was at its height, half of the very bundle of matches by which this mass of national property had been ignited."[39] Although such accusations were never proved, suspicions of political plotting were further fueled by Mr. Cooper, a partner in a Drury Lane iron-founding firm, who announced that he had heard of the fire at Dudley, 119 miles from London, within only a few hours after it began. During the subsequent Privy Council investigation, beginning October 20, 1834, Cooper's statements remained unsupported by any other witnesses and his own testimony became so contradictory that his claims were completely discounted. Twenty-six witnesses were examined in the Privy Council's investigation of the Parliament fire. On November 8 the Council disclosed its conclusions that the fire was accidental, "wholly attributable to carelessness and negligence."[40] The burning of the tallies or, as the Privy Council reported, "the manner in which they were burnt" caused the historic catastrophe. During their disposal the heat was intense enough to ignite dry timbers adjacent to the chimneys of the stoves.[41] The fire then spread to the House of Lords.

What of public response to the devastation? If the *Times* can serve as a barometer, the general mood was not so much sorrow over the ruined structures as it was grateful rejoicing for the preservation of Westminster Hall and Westminster Abbey, buildings "endeared to numerous generations of Englishmen as monuments of the antiquity and glory of their country."[42] While the Parliament buildings were also historic monuments, by 1834 many believed that Parliament's

Figure 35. David Roberts, British, 1796-1864. *The Palace of Westminster from the River after the Fire of 1834*. Oil on canvas, 19-1/8 x 25-3/4 inches, 1834. Museum of London, 63.61.

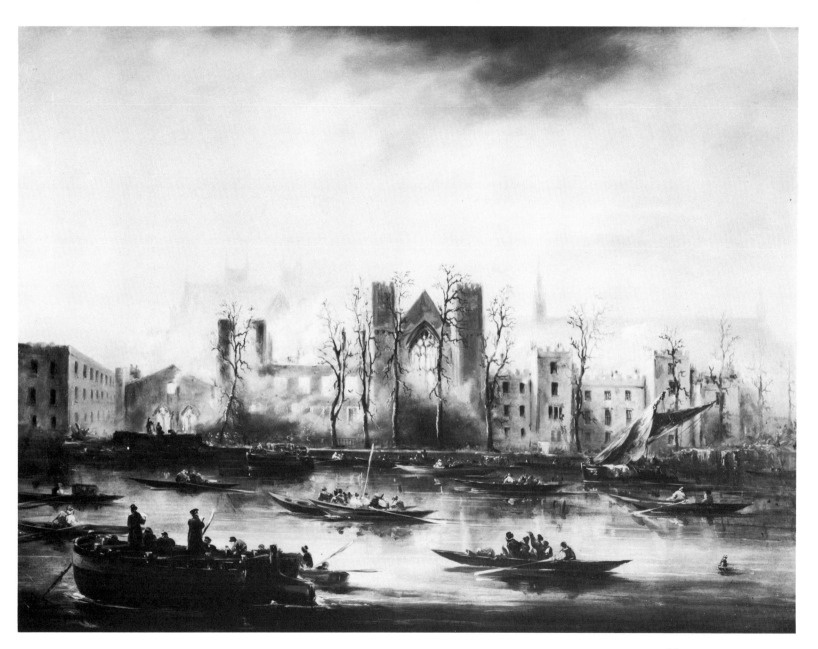

"career of glory" was past and that the walls had now "crumbled over the heads of men who are utterly incompetent and incapable of maintaining it."[43]

Certainly this was not the first time the public had expressed disapproval of the nation's governing body, but to many Englishmen the burning of the Parliamentary seat at this particular juncture served as a kind of poetic justice. Since the eighteenth century, rumblings of discontent had surfaced about the electoral system—an arrangement virtually unchanged since the Middle Ages. Strong public pressure led to passage of the bitterly disputed Reform Bill of 1832, just two years prior to the fire.

The basis of the call for reform had been a recognition that Britain's representational system did not reflect the nation's changing social or demographic structure and that the aristocracy had excessive influence on the electoral process. Whig leaders in Parliament believed that a redistribution of seats in the Commons and an extension of voting rights were necessary to prevent a national crisis. Indeed, strikes and near riots over the issue frequently occurred from 1816 on. Attempting to quell the dissent, the Tory government passed in 1819 the repressive Six Acts.[44] Nevertheless, the outcry for reform continued during the 1820s. Then, in 1830, the anti-reform Tory ministry of the Duke of Wellington was replaced by a Whig government under Lord Grey. This was followed in March 1831 by the first of three attempts to push a reform measure through Parliament. When the second attempt failed in October 1831, the popular reaction was extreme. Demonstrations, riots, and other violence took place in cities and towns all over England. Finally, in the spring of 1832, the Commons approved another reform bill. The Lords approved it as well, at least in principle. When they began to consider it clause by clause, however, the measure came dangerously close to defeat. The prospect of further public disturbances should the Lords fail to approve the bill was by now so abhorrent that King William IV "agreed to create enough peers of a reforming persuasion as should be necessary to get the Bill through. . . ."[45] The Tory Lords, not wishing to be outnumbered by Whigs, conceded and the measure was passed in June.

The Reform Bill eliminated some of the inequities which, over the years, had left many growing industrial towns with no direct representation in the House of Commons, while places with shrinking populations had been sending many more representatives than needed. Enfranchisement was also somewhat broadened.[46] The Reform Bill did not, however, immediately bring about the great social and political changes foreseen by its radical supporters,[47] although Parliament's admission that the electoral system could be altered established an important precedent for introducing future reforms.[48] Supporters of such changes understandably perceived the burning of the medieval Houses of Parliament only two years after the passage of the Reform Bill as a confirmation of the righteousness of their convictions.

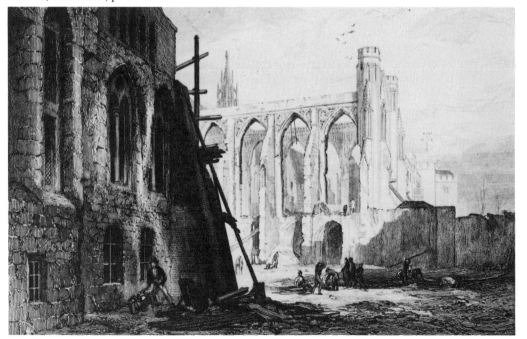

Figure 36. Robert William Billings. *E. End, Painted Chamber, & S. Side St. Stephen's Chapel.* After Brayley and Britton, *Westminster,* pl. XII.

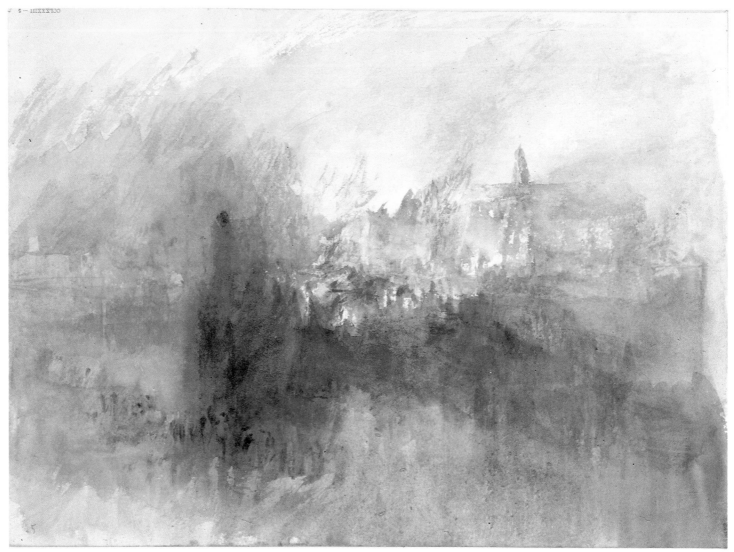

7　*Burning of the Houses of Parliament.* J. M. W. Turner. British Museum, TB CCLXXXIII-5.

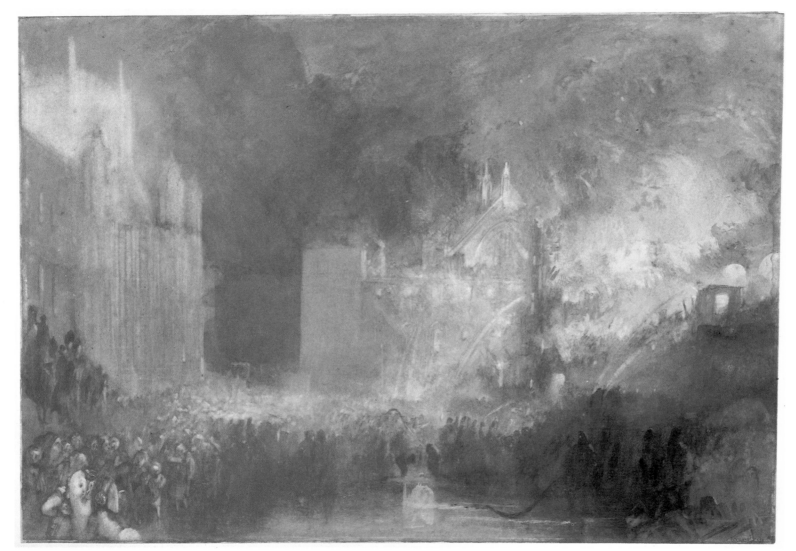

10 *Burning of the Houses of Parliament.* J. M. W. Turner. British Museum TB CCCLXIV-373.

The controversial Poor Law of 1834 was even more immediate in the minds of citizens at the time of the fire. This law, prompted by the belief that the old relief system was too costly, passed despite stiff opposition from the public and press. Although the law provided educational opportunities for the poor and improved health care for the ill and elderly, it ended relief funds for the "able bodied" unemployed unless they entered the newly established workhouses. These workhouses were bitterly hated by most Englishmen.[49] Three years after the law passed, Charles Dickens condemned the dismal conditions inherent in this system with his novel *Oliver Twist*.[50]

It comes as no surprise, then, that two days after the fire, the *Times*, reporting the behavior of Londoners on the scene, mentioned "a ragged looking man, who . . . earnestly asked of everybody that passed him 'whether the Poor Law was burnt?' At length, someone good humouredly took compassion upon him, and no doubt thinking it useless to explain to the inquirer the error under which he evidently laboured, answered, 'that the Poor Law Bill had been saved from the flames.' 'Worse luck then to them as that saved it,' rejoined the man, 'and I wish them as made it and them that saved it was burnt themselves.'"[51]

The mere suggestion that such opinions might have been voiced by spectators observing the fire started quite a debate in the press. The *Times* of October 18 generally praised the overall demeanor of the spectators, noting "They betrayed nothing like a feeling of exaltation at the frightful havoc which was going on around them—quite the reverse." In contrast the correspondent for *Gentleman's Magazine* commented that the crowd showed great concern for the safety of Westminster Hall, but seemed to care little about the destruction of the other buildings on which they "vented their low and reckless jests."[52] The *Examiner* further reported, "instead of regretting the dreadful event as a national calamity, many appeared to consider it a well merited visitation, and actually openly expressed their regret that the Lords and Commons were not sitting at the time."[53] Thomas Carlyle described the scene to

his brother in a letter written several days later: "The crowd was quiet, rather pleased than otherwise; *whew'd* and whistled when the breeze came as if to encourage it; 'there's a *flare-up* for the House of Lords.'— 'A judgment for the Poor Law Bill!'— 'There go their *hacts* (acts)!' Such exclamations seemed to be the prevailing ones. A man *sorry* I did not anywhere see."[54]

Meanwhile the *Times* on October 18 defended the public's right to express their views, saying "Surely our poorer countrymen are not to be prevented from cutting a joke upon the Poor Law Act, or if they do, are not to have their joke construed too severely . . . what great harm was there in remarking, 'There's a bonfire for the Poor Law Bill' . . . ?"[55] And the popular journalist William Cobbett, a long-time critic of the government and the aristocracy, supported this view even more strongly: "when even a dog or a horse receives any treatment it does not like it always shuns *the place* where it got such treatment. . . ." In his *Weekly Political Register*, he added that the crowd might have reflected that injustices were enacted "in this House" and listed some forty-five examples. Among these were the Poor Law and approval of funds to finance "a war to subjugate the Americans." He concluded, "These things have always been present to my mind. Why should they not be present to the minds of the people of London?"[56]

Years later the fire was still mentioned as an important moral lesson for the British government. In 1855 Charles Dickens used it as a metaphor of the need for administrative reform. In a speech to the Administrative Reform Association, he stressed that both the accumulation of the tally sticks over the years and their negligent disposal demonstrated that "all obstinate adherence to rubbish, which time has long outlived, is certain to have in the soul of it more or less that is pernicious and destructive; more or less that will some day set fire to something or other; more or less, which, freely given, to the winds would have been harmless, which persistently retained, is ruinous."[57]

Turner and the Burning of the Houses of Parliament

The spectacular fire at Westminster in October 1834 looms in importance not only because of its historic consequences but also because it provided J. M. W. Turner, while at the height of his creative powers, with a subject fit for his genius. Two sketchbooks—one containing very slight pencil notations and the other nine watercolor studies, possibly done on the spot—seemingly represent the immediate results of his firsthand observations. During the following months he went on to produce a more developed watercolor, two masterful oils, and a vignette of the subject. Such focused concentration on a single theme is not surprising, for Turner habitually explored the imaginative use of cataclysmic phenomena—fire, flood, blizzard, and avalanche—in paintings that reveal nature's elemental beauty as well as her fearful power. But most of these works, though frequently informed by personal experience (the storms in the *Fifth Plague* and *Hannibal*, Figures 3 and 7, for example), depict incidents Turner did not see himself. Since the opposite was true for the fire at Westminster, Turner was able in the two paintings exhibited in 1835 (one at the British Institution and the other at the Royal Academy) to create images of astonishing power and originality. He used the historic conflagration as the starting point for a painterly dissolution of the material reality of the natural world into its basic components—earth, air, fire, and water—which he then reconstituted on canvas in terms of brilliant evanescent color. These pictures thus raise the Parliament disaster to a level of cosmic significance, becoming universal statements rather than mere records. Comparing them with the widely circu-lated prints of the fire emphasizes the telling difference between journalistic documentation and Turner's personally expressive interpretation.

Proof of Turner's presence at Westminster on the night of the fire is found in the diary of a student at the Royal Academy, John Green Waller. The Friday, October 17, 1834, entry reads:

About 8 this morning as I was getting up was attracted by seeing a train of engines attended by mounted policemen on horseback proceeding down the Spa Road, apparently returning from a fire, and soon after a company of soldiers with arms. . . . On arriving at the Academy I there learnt the full extent of our loss and the worst fears too true: both Houses of Parliament had been destroyed by fire. Most of the students had witness[ed] the conflagration, some from the roof of the Academy and others (?) from the river and other places, and they all describe it as being the most grand and imposing sight they ever saw. The appearance of the Abbey lighted up by the flames, they say, was most splen-did and lately a scene of the most terrific grandeur. Some of the students who were on the river were in the same boat with Turner and Stanfield; indeed it must have been a magnificent study for them. The night was for the most part bright moonlight, which added greatly to the variety of effect, and the tide was ebbing at this time and this (?thus) rippling made the grand picture still more perfect. I heard many say the scene from Waterloo Bridge as being the sublimest picture they ever witnessed. The glowing accounts I received from the students made me much regret I was absent from the Academy last night.[1]

Figure 37. J. M. W. Turner. *Burning of the Houses of Parliament.* Pencil, 4 x 6 inches, ca. 1834. Trustees of the British Museum, TB CCLXXXIV-7.

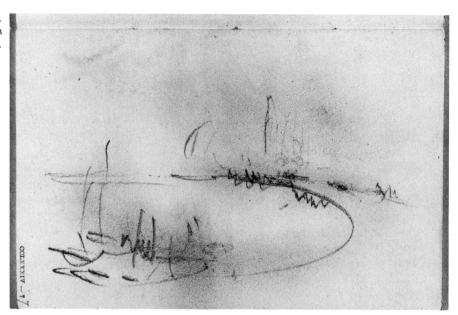

Turner was indeed there and may have recorded his impressions while at the scene, whether from the boat on the Thames or from various vantage points along its banks.

Two sketchbooks and a finished watercolor in the Turner Bequest have been identified as representations of the Parliament calamity, and by examining them Turner's progress in turning experience into art can be traced.[2] The first sketchbook, small in size, contains only a few slight pencil studies. Their summary, ambiguous nature obviously inspires differing interpretations. Are they, in fact, eyewitness sketches of the 1834 fire? It has recently been suggested that the drawings in this book may have nothing to do with the Parliament fire. One noted Turner authority believes they are simply "brief notes of boats along a beach."[3] Although this appears true after only cursory observation, closer examination of two pages (Figures 37-38) reveals images which, though certainly vague, could as easily be construed as rapidly recorded observations of a great blaze. One (Figure 37) might be a distant view of a conflagration, similar to that in the Cleveland oil [12], with crowds or boats near the foreground shore and the fire occupying the middle distance. The other (Figure 38) appears to be a close-up study of a fiery scene. The quickly drawn ovals in the foreground can be read as figural notations, while the upward-slanting jagged lines in the center could represent flames and the tall rectangles at the right might be architectural references.

If these amorphous images are accepted as notations of the fire, further speculations inevitably arise. Did Turner, finding the sight so compelling, dash off these sketches at the scene of the fire? One scholar who has studied Turner's sketching

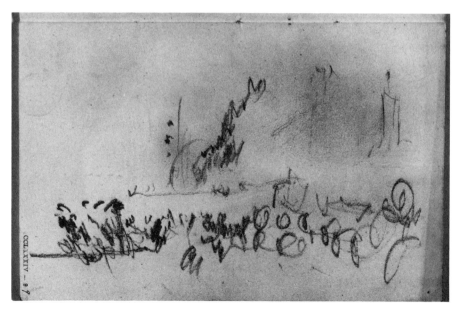

Figure 38. J. M. W. Turner. *Burning of the Houses of Parliament.* Pencil, 4 x 6 inches, ca. 1834. Trustees of the British Museum, TB CCLXXXIV-9.

43

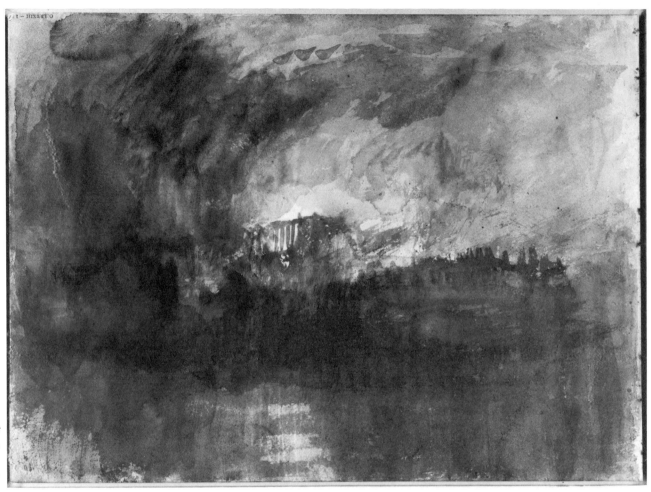

Figure 39. J. M. W. Turner. *Burning of the Houses of Parliament*. Watercolor, 9-1/4 x 12-3/4 inches, ca. 1834. Trustees of the British Museum, TB CCLXXXIII-1.

habits has observed that, after about 1830, the artist's pencil sketches became "more and more a personal shorthand, set down with small regard for pictorial effect: he knows already what he intends to do with the material he records."[4] In the small books that Turner carried about at this time, he tended to put only the minimum number of marks he needed to "jog his memory. Very occasionally the bold lines are softened and flexed as a mood of landscape demands a response, but mostly it is the bare bones of fact that litter the page, disjointed."[5] Taking into consideration Turner's methods of working, it is highly plausible that he made brief pencil notes at the scene of the fire for later reference.

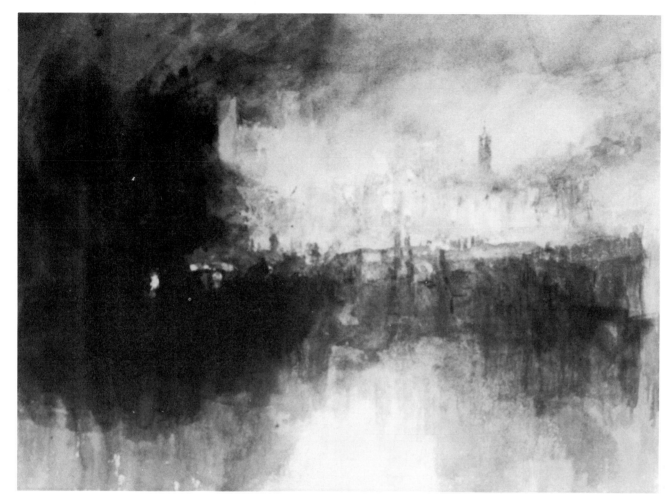

6 *Burning of the Houses of Parliament.* J. M. W. Turner. British Museum, TB CCLXXXIII-2.

The second sketchbook connected with the Parliament fire has also provoked speculation and scholarly debate. This book contained nine watercolor studies now mounted separately ([6, 7, 8, 9] and Figures 39-43) that, like the pencil sketches, do not record specific detail,[6] but do reveal a fascination with color, smoke, and contrasts of light and dark. Also recalling the pencil notes, their nebulous forms engender varied interpretations.

Although it can be argued that these watercolors were also made at the scene of the fire, this would have been contrary to Turner's usual practice. Earlier in his career he did from time to time work outdoors in watercolor, but after about 1810 he

45

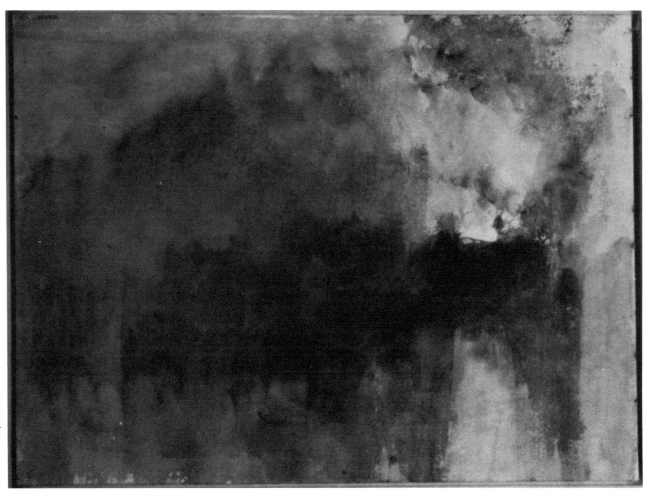

Figure 40. J. M. W. Turner. *Burning of the Houses of Parliament*. Watercolor, 9-1/4 x 12-3/4 inches, ca. 1834. Trustees of the British Museum, TB CCLXXXIII-3.

generally ceased doing so, relying more and more on pencil drawing and his retentive memory. In 1819 he is even supposed to have remarked to a younger artist, while in Rome, that coloring in the open air took too much time—he could do fifteen pencil sketches in the time it would take to produce one colored one.[7] Furthermore, not wanting to be encumbered by more sketching equipment than necessary, Turner usually limited himself to pencils and sketchbooks. On the other hand, two independent incidents, during this same visit to Italy, have been cited when Turner actually did use watercolor outdoors.[8] These studies, however, were not produced on impulse, but were made only after he had had an oppor-

46

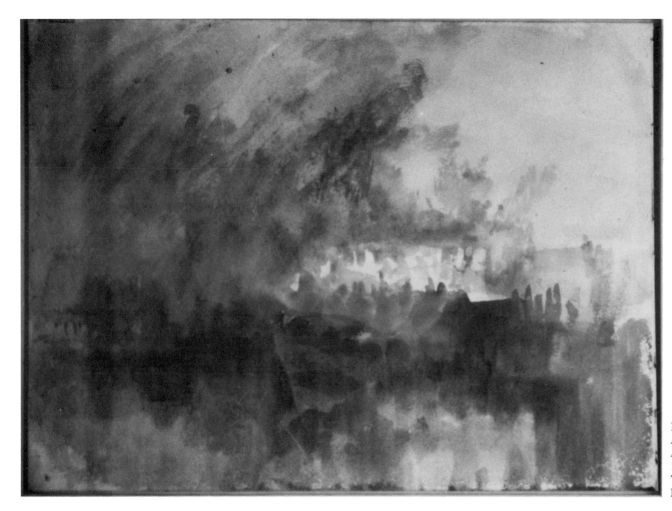

Figure 41. J. M. W. Turner. *Burning of the Houses of Parliament.* Watercolor, 9-1/4 x 12-3/4 inches, ca. 1834. Trustees of the British Museum, TB CCLXXXIII-4.

tunity to contemplate and absorb the visual information before him. It seems that Turner spent some time sketching with R. G. Graves, a medical student and amateur artist, who observed his ability to conceive a mental "preview" of a work to be created: "When they had fixed upon a point of view to which they returned day after day, Turner would content himself with making one careful outline of the scene, and then, while Graves worked on, Turner would remain, apparently doing nothing, till, at some particular moment, perhaps on the third day, he would exclaim: 'There it is,' and seizing his colours, work rapidly until he had noted down the particular effect he wished to fix in his memory."[9] For Turner to

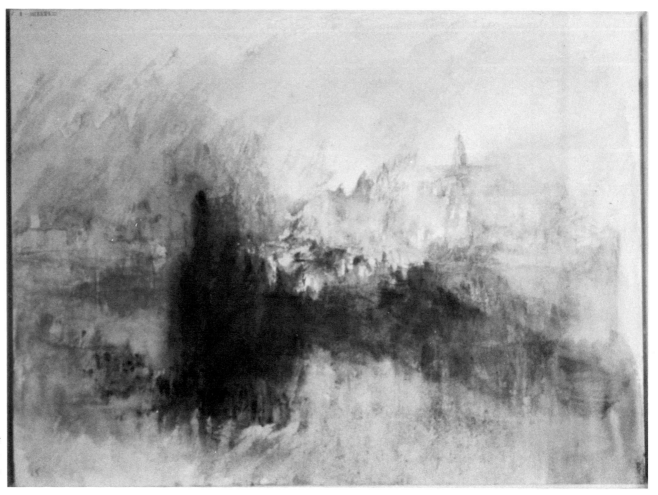

7 *Burning of the Houses
of Parliament*. J. M. W.
Turner. British Museum,
TB CCLXXXIII-5.

have spontaneously produced not just one but nine water-colors while watching the Parliament fire would thus seem to be a significant departure from his usual procedure.

The overwhelming nature of the night's events might, however, have provoked an exception. The physical evidence most often cited to support this view—that Turner executed the watercolors while watching the fire—lies within the original sketchbook. The back of the page facing each watercolor was blotted, suggesting that Turner was working in the open air and rapidly turning over the wet pages. Since 1968, however, it has been generally accepted that these stains may have been caused by the 1928 flooding of the Tate Gallery.[10] If so,

48

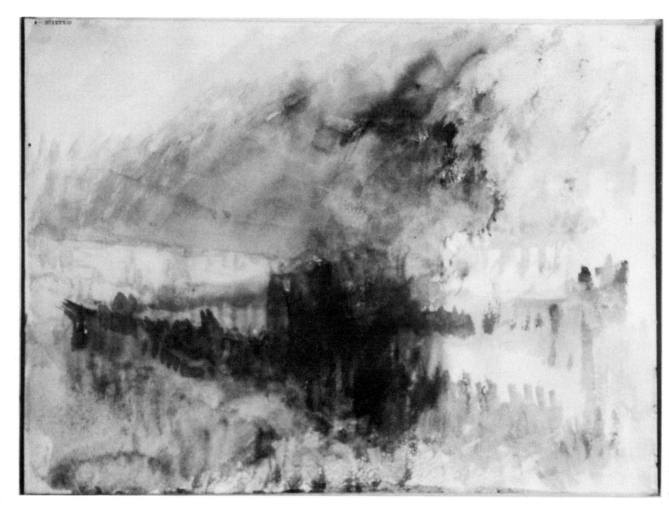

8 *Burning of the Houses of Parliament*. J. M. W. Turner. British Museum, TB CCLXXXIII-6.

this conclusion raises serious questions as to the effects of such water damage on the images themselves. Alternatively, it may be more likely that the blotting occurred in Turner's studio, where working from memory with great imaginative fervor, he wasted no time waiting for the color on each sheet to dry, but quickly turned to the next to capture his thoughts while they were still fresh in his mind. The sketches themselves also vary sufficiently enough in composition that they could represent the artist's musings on possible compositions for a nocturnal scene of fire reflected in water.[11] One scholar has further observed that the breadth of treatment here is "no more remarkable than in many other color sketches of the

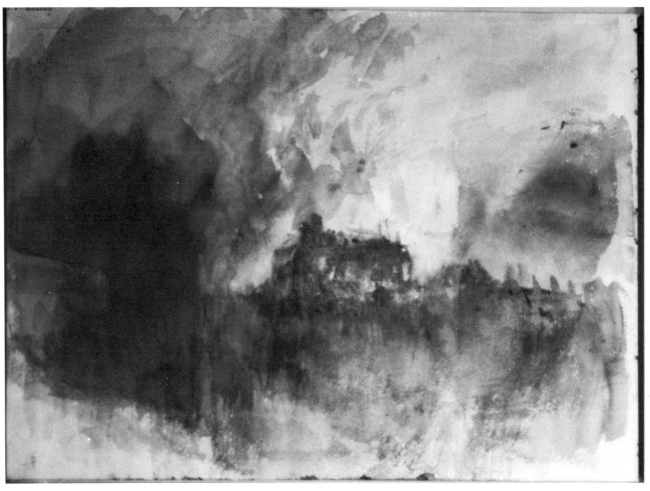

Figure 42. J. M. W. Turner.
*Burning of the Houses of
Parliament*. Watercolor, 9-1/4 x
12-3/4 inches, ca. 1834.
Trustees of the British
Museum, TB CCLXXXIII-7.

same period in Turner's output.''[12] Thus, conclusive physical evidence is lacking to confirm absolutely that these are spontaneous on-the-spot studies.

Doubts have also been raised as to whether or not the watercolors even depict the Parliament fire.[13] Although they all seem to represent fiery scenes, few of the sketchbook images show a definite resemblance to either of Turner's two oil paintings or to other artist's renditions of the fire. The fluid colors of Figures 40-42 do suggest burning architectural forms within an atmospheric setting, but these cannot be related to the fire at Westminster with any certainty. Indeed, in only four of the sketches—[6, 7, 9] and Figure 43—do any shapes

50

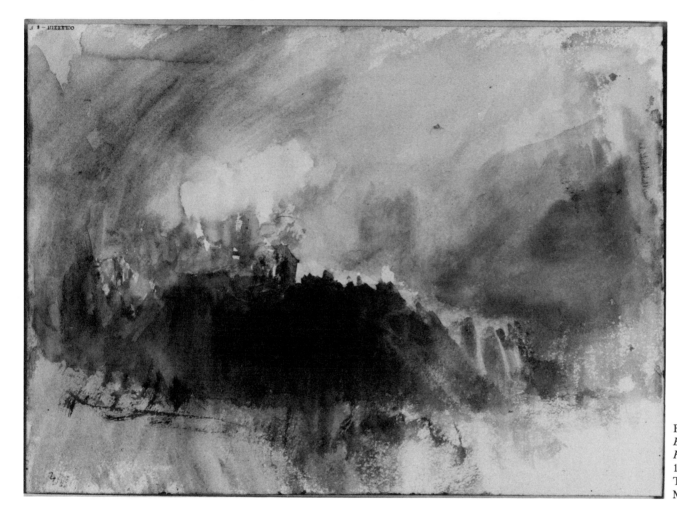

Figure 43. J. M. W. Turner. *Burning of the Houses of Parliament*. Watercolor, 9-1/4 x 12-3/4 inches, ca. 1834. Trustees of the British Museum, TB-CCLXXXIII-8.

appear that can be remotely identified with the Parliamentary complex. Both [6] and [7] could be views of the fire from across the river, representing the roof line and lantern of Westminster Hall towards the right, while in [6] what may be the towers of Westminster Abbey can also be discerned towards the left. Figure 43 and [9] may possibly foreshadow

the composition of the Philadelphia oil [11]: the center of the blaze dominates the left of both sketches and the diagonal strokes at the right intimate the jutting form of Westminster Bridge.

The two remaining studies contain shapes that allude to classical architecture. In Figures 39 and [8] suggestions of

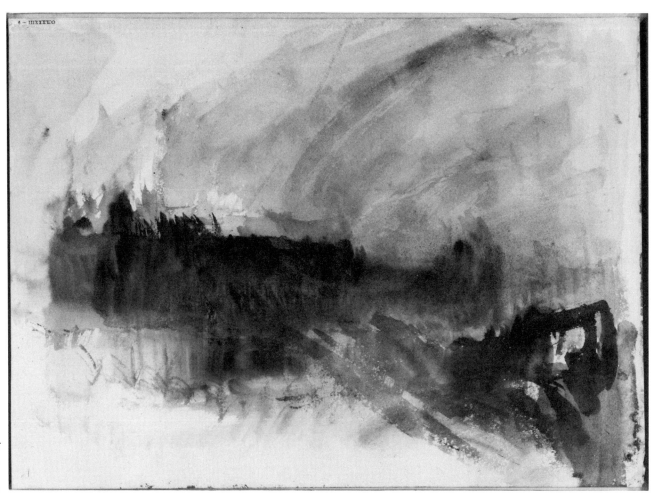

9 *Burning of the Houses of Parliament*. J. M. W. Turner. British Museum, TB CCLXXXIII-9.

columns and entablatures more closely resembling Greco-Roman structures than the British Houses of Parliament are distinguishable within the vaporous colors. Could these watercolors reveal Turner's intention to produce a picture of the Burning of Rome? Another study in the Turner Bequest, which has a suggested date of ca. 1834 (Figure 44), depicts this theme. Perhaps Turner conflated his idea for a *Burning of Rome* with the experience of seeing the Parliament buildings destroyed. Given the political temper of the time and Turner's tendency to draw analogies between contemporary and historical events, he may have felt that such a picture would effectively allude to the present state of the British

Figure 44. J. M. W. Turner. *Rome Burning*. Gouache on brown paper, 8-1/2 x 14-1/2 inches, ca. 1834. Trustees of the British Museum, TB CCCLXIV-370.

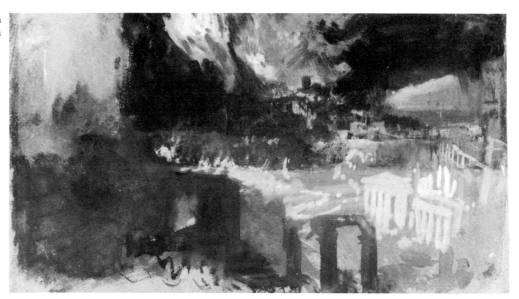

nation thereby warning his countrymen of the consequences of political and moral failure. He never realized such an allegory in a finished work, however, and the two Parliament oils—along with *Keelmen heaving in Coals by Night*, *Fire at Sea* (see Figures 10 and 13), and *Stormy Sea with Blazing Wreck*—were the major results of Turner's meditations on the theme of fire and man at this time.

In contrast to the sketches, with their highly speculative imagery, another work by Turner—a watercolor [10]—is an explicit depiction of the fire. It is much closer to a finished work of art than the sketchbook studies, even though the background flames, smoke, and darkness are almost as broadly and freely treated. Turner may have considered bringing this drawing to a more developed state, for subsequent engraving and publication. Obviously there was a ready market for illustrations of the fire, and this exciting rendition of the Westminster disaster would certainly have enjoyed considerable commercial success, had he ever pursued it.[14]

This watercolor [10] is unlike any of Turner's other depictions of the fire. It shows the interior of Old Palace Yard, looking north, indicating that he had spent some part of the evening on the Westminster side of the river. The Parliament complex is immediately recognizable. Westminster Abbey is on the left; in the center background is the wing of Commons offices and committee rooms, with the peaked roof of Westminster Hall visible behind. In the right foreground, burning furiously, are more committee rooms and passages connecting to the House of Lords. A throng of excited spectators, held in check by soldiers, fills the central portion of the composition. The water from the firemen's hoses shoots up toward the flaming buildings and gushes from a pump in the foreground.

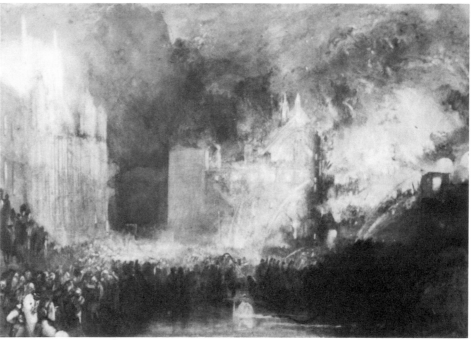

10 *Burning of the Houses of Parliament*. J. M. W. Turner. British Museum TB CCCLXIV-373.

Of all Turner's works relating to the fire, this watercolor conveys the clearest sense of the noise and confusion at the heart of the disaster. The correspondent for the *Gentleman's Magazine* had reported, "Indeed the whole might be imagined to resemble Milton's Pandemonium; the solid walls, presenting numerous architectural apertures, appeared to glow as if red hot with fervent heat. To complete the terrors of the scene, to the above particulars must be added the 'dire yell' when, as Shakespeare says, 'by night and negligence the fire is spied in populous cities,'—the bell of St. Margaret's tolling—the firemen shouting—the crash of falling timbers—the drums of the foot-guards beating to arms, and the clarions of the horse wailing through the air.''[15] A lithograph of Old Palace Yard

by another artist, William Heath (Figure 45), may be more elaborately detailed than Turner's rendering, but it too focuses on the size of the crowd, the efficiency of the soldiers in maintaining order, and the frantic struggles of the firemen.

Within six months of the disaster Turner unveiled the most impressive results of his deliberations on the Parliament conflagration in two powerful oil paintings, both entitled *Burning of the Houses of Parliament* [11, 12]. The one presently in the collection of the Philadelphia Museum is the earlier version, shown at the British Institution's February exhibition. The genre painter E. V. Rippingille (1798-1859) described Turner at work on this canvas while it hung on the walls of the exhibition gallery during one of the varnishing days:

Indeed it was quite necessary to make the best of his time, as the picture when sent in was a mere dab of several colours, and "without form and void," like chaos before the creation. The managers knew that a picture would be sent there, and would not have hesitated, knowing to whom it belonged, to have received and hung up a bare canvas, than which this was but little better. Such a magician, performing his incantations in public, was an object of interest and attraction. Etty was work at his side [on his picture "The Lute Player"] and every now and then a word and a quiet laugh emanated and passed between the two great painters. Little Etty stepped back every now and then to look at the effect of his picture, lolling his head on one side and half closing his eyes, and sometimes speaking to some one near him, after the approved manner of painters: but not so Turner; for the three hours I was there—and I understood it had been the same since he began in the morning—he never ceased to work, or even once looked or turned from the wall on which his picture hung. All lookers-on were amused by the figure Turner exhibited in himself, and the process he was pursuing with his picture. A small box of colours, a few very small brushes, and a vial or two, were at his feet, very inconveniently placed; but his short figure, stooping, enabled him to reach what he wanted very readily. Leaning forward and sideways over to the right, the left hand metal button of his blue coat rose six inches higher than the right, and his head buried in his shoulders

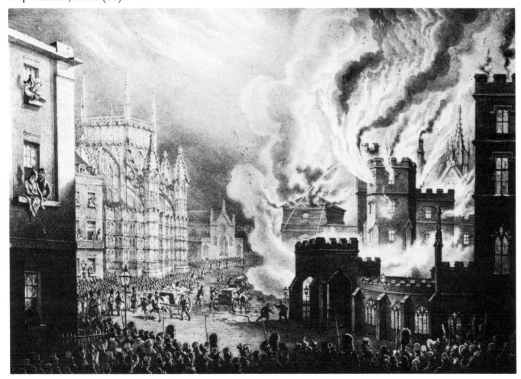

and held down, presented an aspect curious to all beholders, who whispered their remarks to each other, and quietly laughed to themselves. In one part of the mysterious proceedings Turner, who worked almost entirely with his palette knife, was observed to be rolling and spreading a lump of half-transparent stuff over his picture, the size of a finger in length and thickness. As Callcott was looking on I ventured to say to him, "What is that he is plastering his picture with?" to which inquiry it was replied, "I should be sorry to be the man to ask him." . . . Presently the work was finished: Turner gathered his tools together, put them into and shut up the box, and then, with his face still turned to the wall, and at the same distance from it, went sideling off, without speaking a word to anybody, and when he came to the staircase, in the centre of the room, hurried down as fast as he could. All looked with a half-wondering smile, and Maclise, who stood near, remarked, "There, that's masterly, he does not stop to look at his work; he knows it is done, and he is off."[16]

Another painter, John Scarlett Davis (1804-1845/46), also recounted his knowledge of Turner's varnishing day activity: "Turner has painted a large picture of the 'Burning of the Houses of Parliament.' . . . He finished it on the walls the last two days before the Gallery opened to the public. I am told it was good fun to see the great man whacking away with about fifty stupid apes standing round him, and I understand he was cursedly annoyed—the fools kept peeping into his colour box and examining all his brushes and colours."[17]

Both these accounts clearly indicate that Turner's painting on varnishing days was perceived not as simply an instructive demonstration—teaching by example—but as a performance, a virtuoso display of painterly bravado.[18] They also show how free Turner had become in his actual painting process. Unconventional in both style and technique, he was using not only brushes but his fingers and palette knife, and growing more and more assured and spontaneous. In the Philadelphia painting a "close link" has been noted "between the rhythms of composition, the conflicts and harmonies of colours, and the method used in creating them."[19] The same qualities are readily apparent in the Cleveland painting as well. It also imparts the freedom and spontaneity achieved through painting rapidly, but there is no record of its having been completed while on the walls of the exhibition gallery. Certainly its feeling of uninhibited energy might have been achieved just as easily in the artist's studio.

In the Philadelphia painting Turner presents the fire from the opposite bank of the Thames, looking directly at the Houses of Parliament. This same vantage point appears in many of the popular prints (Figure 46, see also Figures 21, 22, 24, 27).[20] The glowing inferno and its reflection in the water illuminate the left half of the canvas and Westminster Bridge, jammed with onlookers, dominates the right. One expert has proposed that the high point of view evident in this version may have been suggested to Turner by a diorama of the event shown at the Queen's Bazaar in late 1834. Conceived by George Lambert, the diorama showed the fire from just above the foot of Westminster Bridge.[21] Although he may have been familiar with Lambert's composition, Turner certainly could have viewed the scene from this spot either during the night of the fire or later, as he was planning his own rendering. Clearly, the final picture must be considered an amalgamation of art, experience, and imagination.

The lighting effects of the Philadelphia oil, and indeed many other aspects of Turner's rendering, closely correspond to the details emphasized by various journalists reporting on the fire. For example, a correspondent for the *Times* wrote on October 17 that "Westminster Bridge, covered as it was with individuals standing on its balustrades, was a curious spectacle, as the dark masses of individuals formed a striking contrast with the clean white stone of which it is built, and which stood out well and boldly in the clear moonlight." Although seemingly an illustration of this passage, Turner's portrayal betrays the artistic license he took with the bridge's form to achieve a grand effect. Greatly exaggerated in scale, it rises toward the center of the picture, apparently permanent and stable, but then collapses abruptly before the far bank, as if its massive structure is dissolving in the incandescent heat of the fiery blaze. As will also become evident in the following

discussion of the Cleveland picture, Turner usually allowed himself considerable freedom to change the particulars of a scene if in doing so he heightened the pictorial and poetic expression of his work.

Echoing another portion of the *Times* description, the Philadelphia version [11] shows ''an immense pillar of bright clear fire'' shooting upward, sending a shower of blazing cinders into the sky. St. Stephen's Chapel is clearly visible at the center of the flames, glowing as if molten, and flanked on either side by disintegrating buildings. The towers of Westminster Abbey, illuminated by the flaring radiance before them, are in the background. Turner even seems to have accurately portrayed the direction of the wind, which sweeps billowing smoke in a northeasterly direction to the right. According to the *Times*, after about eight o'clock, ''the volumes of fire, sparks, and smoke . . . were carried away in the direction of Westminster Bridge.''[22] The wind's direction was also noted in the popular prints of the fire and is particularly vivid in Picken's lithograph (see Figure 22).

Turner completed his chronicle of the fire by including the watchful throng positioned in the foreground and on the bridge. This crowd, along with the boats on the river, also recalls both written accounts and popular illustrations of the fire. But for Turner—in keeping with the practice first established with the early *Pantheon* watercolor (Figure 1)—these figures are here for more than reportorial accuracy. One scholar has compared the Philadelphia painting to a Romantic opera, ''with elaborate scenery and a full chorus of horrified spectators.''[23] Indeed many of the assembled multitude, especially in the right half of the picture, look not at the fire, but toward the viewer—their awe-struck faces clearly visible. This ''chorus'' of figures is essential to the painting, for it not only frames and balances the lower half of the composition, but it also conveys the conflicting emotional responses of the witnesses. Their outward stares draw the viewer into the picture as fellow witnesses to the scene, instilling a sense of participation in the spectacle. The diminutive scale of the figures is also important for, as in many of

Turner's earlier depictions of catastrophes (see Figures 3-5, 7-8, 13-15), they symbolize the insignificance of mankind before nature's supreme destructive force.

Turner rendered the assembled spectators in the Cleveland version [12] in a similar manner. Here, however, they are confined almost entirely to the outermost edges of the picture, leaving a great expanse of canvas for the flaming apparition in the center which, enhanced by its reflection in the water, threatens to consume the entire scene. Here, too, a number of wide-eyed, open-mouthed faces turn away from the inferno toward the viewer. Occasionally one can discern specific gestures such as pointing arms or hands raised to the face, as if accompanying exclamations of awe or alarm.

This second oil rendering of the *Burning of the Houses of Parliament* [12] was exhibited at the Royal Academy in May 1835, only three months after the first version was shown at the British Institution. Why Turner should have departed from his normal practice and produced two paintings of this single event is by no means certain. Both compositions may simply reflect his fascination with the phenomenon of flame and smoke mirrored in water, which was also demonstrated in another entry to the same Royal Academy exhibition, *Keelmen heaving in Coals by Night* (see Figure 10). Perhaps Turner also wished to capitalize further on the strong emotional responses of his countrymen to the historic events of the previous year. With an eye toward continued commercial success, his choice of the Parliament disaster as the subject for a second work may have been partially motivated by a desire to enhance his popular reputation.

A more likely reason for the second version, however, would seem to be that while working through the first Turner was so excited by the subject that he had to exploit its potentialities even further. The result was the Cleveland painting which, in contrast to the Philadelphia version, presents a panoramic view of the fire, as it appeared from the south end of Waterloo Bridge, looking upstream toward Westminster Bridge. Perhaps Turner's topographical work conditioned him to paint these near and far views of the same scene;

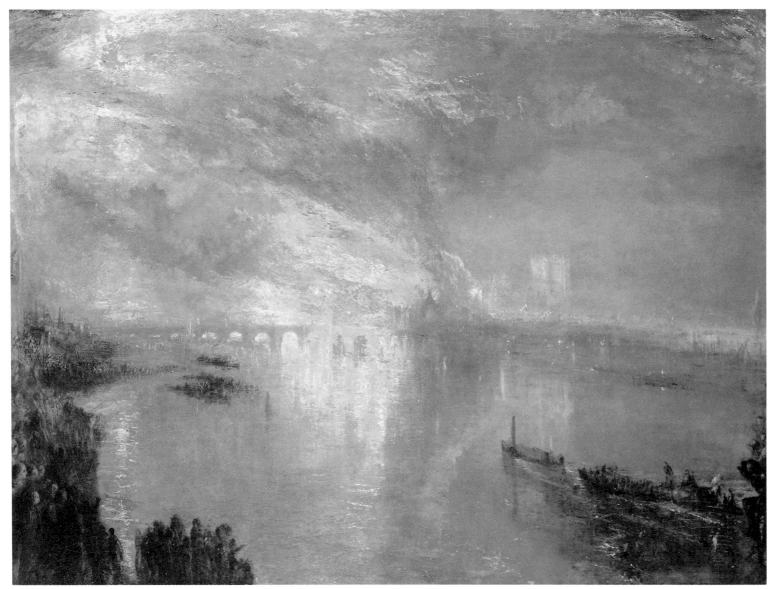

12 *Burning of the Houses of Parliament.* J. M. W. Turner. The Cleveland Museum of Art, CMA 42.647.

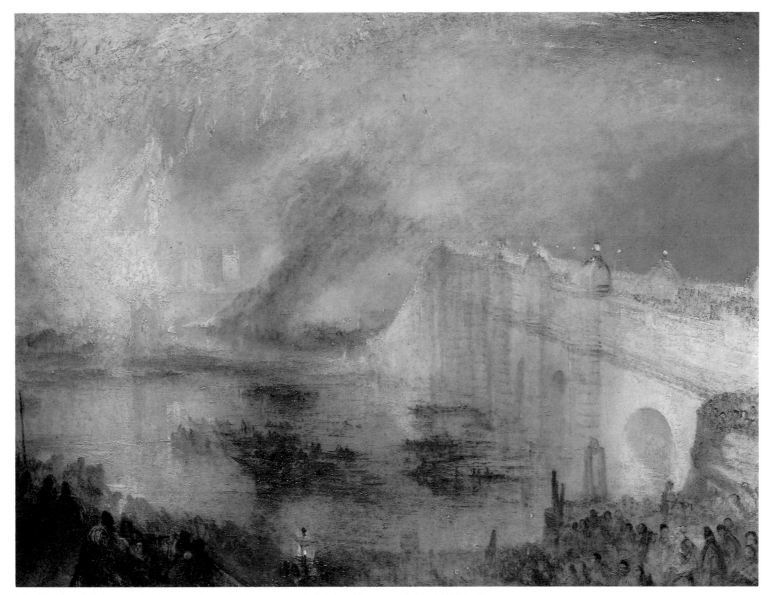

11 *Burning of the Houses of Parliament.* J. M. W. Turner. Philadelphia Museum of Art, M'28-1-41.

certainly one of the habits developed during his sketching tours was to walk around a site in search of the best view. In the case of the Parliament disaster, his wanderings throughout the course of the night may have led to the conclusion that there were two, equally powerful views. The closer vantage point allows the viewer an almost direct confrontation with the blaze itself, while the distant prospect provides more scope for Turner's characteristic obliteration of the distinction between material, man-made monuments and nature's elements.

In the Cleveland painting everything seems to merge in the center of the flames. Westminster Bridge, relatively substantial at the left in tones of blue and green, appears to dissolve into the burning yellows, ochres, and oranges in the center of the composition. The Parliament buildings are nearly impossible to identify with the exception of Westminster Hall which appears to coalesce with the surrounding glow. Once again, those symbols of English pride—the towers of Westminster Abbey—stand by like paired sentinels, reflecting the intense light, but remaining unscathed by the fire itself. The great arc of thickly painted flames sweeping across the night sky is magnified to a grander scale by the reflection of its image in the river below. In both paintings this mirroring of sky, flames, and clouds on the water's surface suggests a complete fusion of the natural elements. As John Canaday put it, "Water fuses with air, air and water fuse with fire, while earth, stone, and metal dissolve into all of them."[24]

It thus appears that Turner was expressing a feeling of exaltation rather than desolation, for these dazzling canvases look more like celebrations than tragedies. As noted in the *Gentleman's Magazine*, many spectators at the scene even clapped, as if they were witnessing a fireworks display. This is not to say that Turner was unmoved by the horror of this catastrophe—or any other he represented—but simultaneously attracted and repulsed, he projected in his paintings both the terror and the fascination of disaster. As in his portrayals of shipwrecks or snowstorms, there is a certain measure of irony in both Parliament oils, for on the one hand the fire was a national tragedy, but on the other it presented a magnificently orchestrated visual experience that inspired Turner to create a splendid symphony of color.

To achieve this pictorial splendor and convey a universality of meaning, Turner sacrificed topographical accuracy in the Cleveland version, just as he had done in the Philadelphia painting and, indeed, as he had done since his earliest watercolors. Here, for example, gigantic flames dwarf the buildings, reaching far into the sky and casting an unearthly glow over the hordes of observers. Turner also straightened the curve of the Thames between Waterloo and Westminster bridges (see map, page 10). A lithograph depicting nearly the same view, eight years later [16] (see Epilogue), reveals that Turner's view of the fire is practically impossible. When looking toward the blaze from the south end of Waterloo Bridge or the crowded bank below, the factory buildings located just at the bend of the river at the left (which also existed at the time of the fire) would have almost entirely obscured Westminster Bridge, a fact Turner appears to have ignored. But again, such matters were unimportant to him. He frequently altered an observed landscape, either compressing or expanding it according to the dictates of his composition in tandem with his imagination.

Turner's imagination controlled his treatment of another detail of the scene, the moon, which, for many witnesses to the fire, was an integral part of the experience. Appearing in several of the popular prints (see Figures 18, 28, 46), it is specifically mentioned in published accounts of the evening's events. The correspondent for *Gentleman's Magazine*, for example, wrote that the moon "in unruffled majesty rode through the skies 'apparent Queen,' her pale and silver light overpowering that of the glowing furnace. . . . " He continued in a footnote: "So far from the light of the fire extinguishing that of the moon, as some inflated accounts of the Journalists the next day stated, the flood of light from that luminary, then within a day of the full, greatly subdued that of the flames, and confined the atmospheric reflection[s] to the quarter whence they proceeded."[25]

And yet when Turner produced his two oil paintings of the fire, he did not include the moon in the Philadelphia version [11], although its presence is strongly suggested by the overall illumination of the scene. Likewise, the moon is not directly visible in the Cleveland painting [12], but its reflection on the river is easily discernible at the lower left. The orb itself is obscured by clouds, flames, and smoke surging through the sky above. Turner has thus sharpened the horror of the event by rendering the results of man's folly as temporarily overwhelming the moon. This subjugation of fact to artistic imagination epitomizes Turner's approach. He strove, above all else, to communicate in terms of grand summarizing statements, going beyond literal appearances to achieve a broad cosmic view.

In the two oils Turner did, however, pay close attention to certain other specific details of this compelling scene. For example, it has been argued that he arbitrarily changed the true direction of the flames to emphasize their reflections in the water.[26] Yet in actuality, the wind had shifted early in the evening, blowing the flames northeast over Westminster Bridge for most of the night, as seen in the Cleveland painting. Another important detail is the visibility of Westminster Hall in the midst of the inferno. Even though Turner may have simply been documenting a specific moment during the evening he must also have been responding to the Hall's historic importance and the crowd's overwhelming concern of its safety. Acknowledging the role the Hall had played in this great drama, Turner carefully highlighted its presence in the center of the holocaust.

In a similar manner, the prominence of St. Stephen's Chapel in the Philadelphia painting may have been intended as a reminder of Parliament's medieval foundations, recently shaken by the Reform Bill of 1832 and now literally going up in smoke. Whether Turner himself supported Reform is not absolutely certain. It is known, however, that his close friend and patron, Walter Fawkes, was an outspoken partisan of radical politics.[27] During his many visits to Fawkes's Yorkshire home, Turner would have heard his friend's opinions on current affairs. Evidence has been found that Turner may have sympathized with the progressive strain in British politics and on several occasions even addressed issues such as the Reform question and Catholic emancipation through his art. A number of drawings from the 1820s and 1830s made for the ''England and Wales'' series may contain allusions to the contemporary political and social changes taking place in Britain at this time.[28]

A curious detail in the Philadelphia painting may fit this pattern of political response. In the center foreground of the composition a sign protrudes above the crowd, facing the viewer. Perhaps it is simply a posted notice, forbidding trespassing, for example, but only one word can be made out—a very large *NO*. It has been suggested that this may refer to opposition to the Poor Law which, as was noted earlier, was under discussion in Parliament at the time of the fire.[29] Perhaps Turner, like many of his countrymen, saw the burning of the center of government as both symbolic of the triumphant reform of the old parliamentary system and a measure of the intense, popular response to the legislative acts that followed, among them the Poor Law. Thus the two paintings can be interpreted as either profoundly optimistic, looking toward a brighter future for England or, as one scholar has phrased it, ''symbolically expressive of the fires of decay and violence in English society and liable to burst out in a general conflagration.''[30]

All incidents surrounding the dramatic burning of the Houses of Parliament were, in fact, subject to political interpretation by the press and governmental critics. The floating fire engine, for example, that did not arrive at Westminster until almost 1:30 a.m. came to be viewed as a metaphor for lethargic parliamentary action. As noted previously, the shallowness of the river impeded the engine's progress from the Rotherhithe docks. It was, of course, hours too late to save the Houses of Parliament. The *Examiner's* comments typify press interpretations of the incident:

We cannot help saying that, lamentable as this accident has been, it will not be without further uses . . . if it presents to

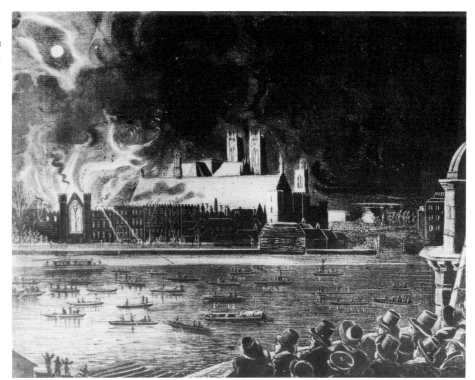

Figure 46. *Burning of the Houses of Parliament, from Westminster Bridge*. Colored woodcut, 14-1/8 x 10-7/8 inches. Westminster City Libraries, Archives Department, Box 57 No. 15.

the Lords a type of political perils. In their House the cause of destruction originated; the combustible materials of this House first spread the flames, and the swamping expedients came too late to save. . . . A floating fire engine was towed up of prodigious power, and having only the one fault of arriving too late—it was well prepared, deliberate in its approach, avoiding all shoals and shallows, but a squirt, while it was in its slow progress, would have been as serviceable; and, in political exigencies, we have had the squirt with the much ado instead of the late but potent engine. The whole calamity reads like an allegory.[31]

The floating fire pump is significantly featured in the right foreground of the Cleveland painting (Figure 47). On its side a sun emblem appears between the words *SUN* and *FIRE* which identifies the engine with the Sun Fire Insurance Office. This apparatus, with its lettering, is also clearly visible in one of the popular prints (Figure 46). Turner may have been aware of the political overtones surrounding the late arrival of the floating engine and perhaps positioned it prominently in his work to reinforce these interpretations. He may have also intended a greater allegorical statement, emphasizing the irony of a situation in which man's efforts were futile in the face of the relentless forces of nature. Such a message would certainly be consistent with his earlier works including *The Shipwreck*, 1805; *The Fall of an Avalanche in the Grisons*, 1810; *Snow Storm: Hannibal Crossing the Alps*, 1812; and *Eruption of the Souffrier Mountains*, 1815. That Turner should now choose a topical event for conveying this theme is also consistent with his general working practice during the 1830s and into the 1840s.[32]

Figure 47. J. M. W. Turner. Detail of *Burning of the Houses of Parliament* [12]. The Cleveland Museum of Art, CMA 42.647.

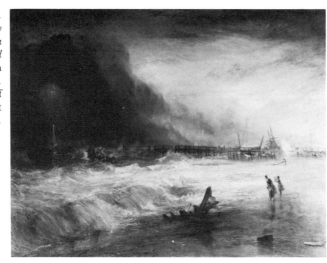

Figure 48. J. M. W. Turner. *Life-boat and Manby Apparatus going off to a Stranded Vessel making Signal (Blue Lights) of Distress*. Oil on canvas, 36 x 48 inches, exh. 1831. London, by courtesy of the Victoria and Albert Museum, 211.

Figure 49. J. M. W. Turner. *Slavers Throwing Overboard the Dead and Dying: Typhon Coming On (The Slave Ship)*. Oil on canvas, 35-3/4 x 48 inches, exh. 1840. Courtesy of the Museum of Fine Arts, Boston, Henry Lillie Pierce Fund, 99.22.

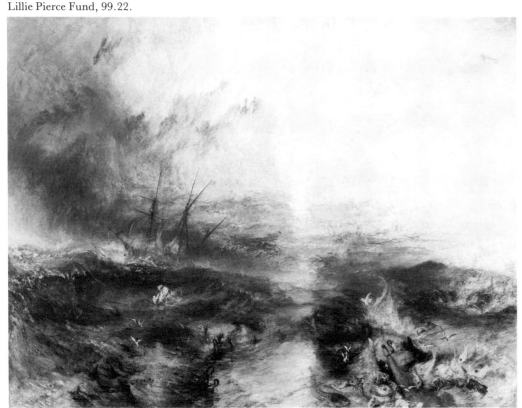

Turner's *Life-boat and Manby Apparatus going off to a Stranded Vessel making Signal (Blue Lights) of Distress* (Figure 48), was exhibited at the Royal Academy in 1831, the year George William Manby (1765-1854) was elected a Fellow of the Royal Society. After witnessing a disastrous shipwreck at Yarmouth in 1807, Manby had invented an important lifesaving device. A stone at the end of a rope was fired from a mortar on shore, providing a lifeline to a ship in trouble. In Turner's dramatic tribute to Manby, based on sketches made at Yarmouth in 1824, the rocket with the lifeline is just visible at the left against the dark sky, not far above the foundering ship sending up a flare. This work, like the Parliament pictures, shows Turner reaching beyond the specifics of the moment to incite an emotional reaction in the viewer. He exploits dynamic lines, restless forms, and turbulent colors to convey his theme of man's battle against the powers of nature.

In the 1840s the subjects of Turner's pictures, including those taken from the world around him, were even further transformed into expressive allegories. The *Slave Ship*, exhibited in 1840 (Figure 49),[33] is one of the best examples. Intended as a denunciation of the slave trade, the picture was probably inspired by an incident that Turner may have just read about. When an epidemic broke out in the slave ship *Zong* in 1783, the captain had ordered much of his human cargo to be thrown overboard, because he was insured if the slaves were lost at sea, but not if they died on board his ship. After being hurled into the ocean, the captives became the prey of sharks. At the lower right of Turner's picture a manacled leg is surrounded by the devouring creatures. Again the specifics of the scene are summarized to heighten the emotional intensity of the moment and details have been subsumed in a flood of paint and color. And once again, Turner chose a theme affording him an opportunity to create a majestic, even terrifying image of wind and sea. It is no wonder, given the powerful synthesis of the various elements, based on a thorough understanding of nature, that this painting should have been viewed as Turner's greatest achievement by its proud owner, John Ruskin.[34]

Although representational forms may be nearly abandoned in these paintings dating from the 1830s and 1840s (see also Figure 15), the sheer force of Turner's brushwork makes their imagery all the more convincing. In the *Burning of the Houses of Parliament* oils, one might notice the contrast between the relative precision of the foreground details and the less distinct handling of the flames and the burning structures. The result is a suggestion of blurred movement. Turner employed this technique to great effect many times in his paintings. It has been characterized as a means by which "the eye is both engaged and confused in a way analogous to the visual effect of the event itself."[35] The eye can thus accept the image as truth, even if it lacks journalistic detail.

The *Atheneum* critic reviewing the 1835 Royal Academy exhibition failed to recognize this enhancement of meaning through technique and wrote, in summation of the Cleveland version of the *Burning of the Houses of Parliament*, "in extravagant words, an extravagant picture may be criticized." He would have preferred to see "the accuracy of a district survey."[36] The reviewer for the *Examiner* thought similarly, yet also realized that Turner's paintings could be appreciated if one stood the proper distance from them. Describing the Philadelphia version he wrote that close up it seemed "struck off . . . in a heap of huge daubs, but forcing itself out as the spectator retreats, in a series of masterly effects which gradually combine into a magnificent clearness of light and colour."[37]

Reviews of both pictures were rather mixed. Inevitably, anyone seeking a detailed factual recording of the event was disappointed. Visitors to the British Institution and the Royal Academy were, in fact, dismayed by the disparity between their memories of the fire and Turner's recreations of it. In reviewing the Philadelphia version for the *Atheneum*, a critic called it "a splendid impossibility" and commented that "the sky is of a noon-day blue, and truth is sacrificed for effect, which, however, is in parts magnificent."[38]

The most sensitive review of the Philadelphia painting is the one appearing in the *Literary Gazette*, which begins with the observation that the picture's subject was "furnished at the heavy expense of the public." The writer went on to say that Turner had portrayed it "in a manner of which no other artist is capable. It is not any striking opposition of light and dark, it is the contrast of warm and cold, of the blazing flame and of the early morning before 'the stars are all burnt out,' that gives magic to the scene, which manifests quite as much of vision and poetry as of nature."[39]

The freedom of the Cleveland version posed some problems for the critic writing in the *Morning Herald* of May 2: "We seriously think the Academy ought, now and then, at least, to throw a wet blanket over either this fire king or his works; perhaps a better mode would be to exclude the latter altogether, when they are carried to the absurd pitch which they have now arrived at. . . . "[40] The *Times* observed that Turner's "fondness for exaggeration" had here "led him into faults which nothing but his excellence in other respects could atone for."[41] The *Burning of the Houses of Parliament* was a "great curiosity" to *Fraser's Magazine*: "The light is that of an English November day, while the flames are of more than November dullness. As the poetic style disdains to be cramped by matters of fact, we must, we suppose, excuse Mr. Turner for his pictorial amplification of the scenery, and the daring license and liberties he has taken with perspective, which do not exactly become one who is a professor of it."[42]

Turner's response to these reviews is unknown. He was generally sensitive to criticism, however, and an incident occurring seven years later demonstrates his sharp reactions to it. John Ruskin recounted one critic's comment about Turner's *Snow Storm* . . . (see Figure 15) saying that it was merely a "mass of soapsuds and whitewash." Turner's retort was, "What would they have? I wonder what they think the sea's like? I wish they'd been in it."[43] In answer to complaints that the effects in the paintings were too close to daylight Turner could have quoted the *Times* correspondent who wrote that "the light reflected from the flames of the fire as it shone on the Abbey and the buildings in the vicinity had a most extraordinary effect, and every place in the neighborhood was

visible, so that a person could have been enabled to read as in the day time.''[44] Indeed, one can recite a litany of details in both pictures closely related to the actual facts of the fire.

Despite the lack of universal critical approval the two paintings found buyers in 1835. The Philadelphia version was purchased from the British Institution exhibition by Chambers Hall and the Cleveland version directly from Turner by John Garth Marshall of Headingly, Leeds. Mr. Marshall's grandson later related the following anecdote:

> This picture was painted in the year 1835, and in that year my grandfather, Mr. James Garth Marshall, took his son, Mr. Victor A. E. Marshall (my father) to Turner's studio. My grandfather asked Turner what his price was and he said he could have anything in his studio for £350. My grandfather then turned to my father and said, ''Which do you like best?'' and he pointed to the picture now in my possession. But Turner said: ''Well, young man, that is the one you cannot have, as I have decided to give that one to the nation,''—but my grandfather, who was a hard-headed Yorkshireman, said: ''No, Mr. Turner, you gave me the offer of anything in your studio at a price and I must hold you to it.'' And so the picture came into the family and it has never been out of my family from that date . . . I, myself, have received one offer from a local furniture dealer of £27, frame included![45]

The Parliament fire has been called ''one of the climactic experiences of Turner's life.''[46] From it he discovered that contemporary events could lead metaphorically to the realization of profound personal truths. Thus, his firsthand encounter with a spectacle of epic proportions inspired two masterpieces, both of which retain great historic and artistic significance. First of all, they document the dreadful fire of 1834 by offering effective visual commentary on English political and social struggles during the first half of the nineteenth century. Secondly, and more personally, they exemplify the persistent attraction of one artist, J. M. W. Turner, to the theme of the insignificance of man before nature's fury. Finally, they epitomize one of the essential preoccupations of his art—the exploration of the richly expressive possibilities of paint and color for rendering immaterial forms such as light, air, water, and fire. Turner transformed the specifics of a moment in time into an eternal reality in paint. The fire that destroyed the buildings at Westminster has become more than a particular incident—it is a sweeping maelstrom of pure cosmic energy, a wondrous source of astonishing heat and light, possessing the power to melt, disintegrate, consume, and transform. As the critic in the *Atheneum* ruefully pointed out: ''Of the thousands and tens of thousands who saw those ancient edifices Redden the midnight sky with fire, not one of them, we would be sworn, thought the scene half so portentous—nay, supernatural, as the artist has delineated it on his canvas: flames flashing out, of a far fiercer nature than ever earthly fuel could produce; and the air above, and the river below, may be said to express surprise at the sight. . . .''

The Cleveland and Philadelphia paintings may thus represent Turner's grandest thoughts on the subject of the Parliament fire, but more was still to come. Later in 1835 he exploited the commercial possibilities of a published print. As noted earlier, he did not use his large watercolor of the fire [10] for reproduction, deciding instead to pursue a small steel-engraved book illustration based on a completely new image. As with all his publishing ventures, Turner was encouraged not only by the financial rewards that would be forthcoming but by the realization that through inexpensive prints he could reach the vast public outside London that had neither witnessed the fire nor seen his oil renderings of it.

Steel engraving had first been used to illustrate books in the early 1820s. The hardness of the metal permitted a virtually unlimited number of impressions to be taken from the plate, a fact which appealed greatly to publishers who wanted to produce large editions. It also gave a silvery brilliance and luminosity to the printed image which soon attracted Turner, who for many years had been illustrating books with engravings on copper. Here at last was a medium that could nearly reproduce in black and white the feeling of light and air that he strove to capture in his paintings.

Turner's extensive output as a book illustrator includes the

drawings he made for such literary volumes as Samuel Roger's *Italy* (1830) and *Poems* (1834), Sir Walter Scott's *Poetical Works* (1832-34), and the *Life and Works of Lord Byron* (1833-34). In addition, he contributed numerous illustrations to annuals such as *The Keepsake*, the *Amulet*, the *Literary Souvenir*, and others which were very much in vogue between the late 1820s and the early 1840s. Published in the fall of each year, the annuals—comprised of short stories, essays, and poems, illustrated with engravings—were used as gifts for Christmas, New Year, and other special occasions by the fashionable middle class. *The Keepsake* was the best-known and the longest-running of these giftbooks, published over a thirty-year period. It was also one of the most attractive, with red watered-silk binding and gilt-edged pages. Many leading writers, including Scott and William Wordsworth, were persuaded by the publishers to contribute selections, but *The Keepsake's* success was largely due to the quality of its engravings.[47]

Turner's watercolor vignette of the Parliament fire [13] was drawn to illustrate a poem by *The Keepsake* editor, the Honorable Mrs. Norton, called "The Burning of the Houses of Lords and Commons."[48] The engraved version [14], which appeared in the annual for 1836, was produced by J. T. Willmore (1800-1863), a skilled professional who always worked under the artist's supervision and engraved more plates after Turner than any of his other contemporaries.[49]

The compact, upright oval form of a vignette, with the image melting off into the surrounding page, was a popular format for book illustration and one that Turner had first used for Scott's *Poetical Works*.[50] The composition of the Parliament fire vignette [13, 14] centers on a large, elliptical area of bright light and shows the fire from the river, framed by an arch of Westminster Bridge. In the foreground some spectators observe from boats while others cling to the side of the bridge to get a better view. The towers of Westminster Abbey are illuminated at the right, and in front of them Westminster Hall and the Speaker's House are engulfed by billowing smoke. In the background, just beyond St. Stephen's Chapel,

brilliant flames can be seen devouring the Commons' Library and the Painted Chamber. Although it successfully conveys a sense of the spectacular horror of the fire, this image, created for a popular audience, also has an almost picturesque quality far removed from the apocalyptic overtones of Turner's two oils. Furthermore, because it was intended for engraving, the vignette is far more detailed than those works. Comparing the original drawing [13] with the published version [14] reveals the changes that must occur in the conversion from watercolor to engraving.

Turner's vignette of the Parliament fire recalls John Green Waller's diary account which, as noted earlier, provides evidence that the artist spent at least a portion of the evening of October 16 in a boat on the Thames, observing the blaze from water level. A description of a similar view of the fire appeared in the *Times* the following day: "As you approached the bridge you caught a sight through its arches of a motley multitude assembled on the Strand below the Speaker's garden, and gazing with intense eager on the progress of the flames. . . . As soon as you shot through the bridge, the whole of this melancholy spectacle stood before you."[51] It has been suggested that Turner may have had this description in mind when he began composing the vignette, especially since none of the drawings in the sketchbooks record the scene from this vantage point.[52]

Another portrayal of the fire [15] by an unknown artist, which has been dated ca. 1834, shows compositional similarities to Turner's vignette and indicates that many witnessing the disaster saw it through the arches of Westminster Bridge.[53] The vantage point for the small panel from the Walters Art Gallery, however, is on the bank opposite the Parliament complex, rather than on the river itself. The composition also includes small clusters of spectators, several boats, and a barge carrying the large wooden derrick that may also be depicted at the right of Turner's *Burning of the Houses of Parliament* [11] in Philadelphia. This apparatus apparently belonged to the boat-yard located just south of Westminster Bridge. The early history of exhibition and ownership for the

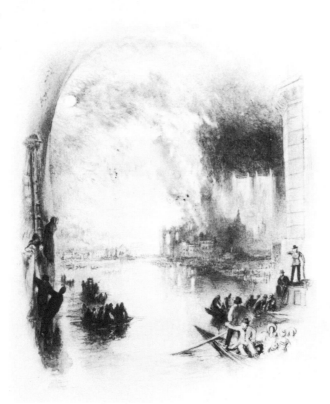

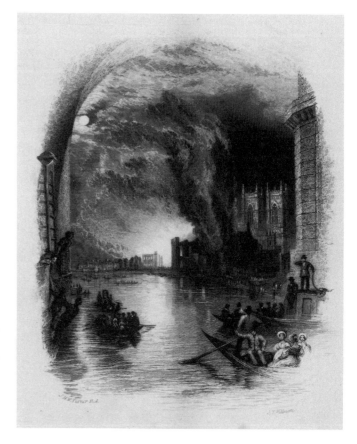

Walters picture is not known, so it is impossible to determine if Turner had ever seen it. This rather naïve picture is probably just one of the many conventional images produced in the wake of the disaster by artists eager to supply a popular demand.

The compositions of both Turner's vignette and the Walters panel are interestingly prefigured in an earlier painting, depicting another historic fire. In 1797 Philip James de Loutherbourg (1740-1812) painted a large historical picture, *The Great Fire of London in 1666* (Figure 50). It features a view of the city from beneath London Bridge, one of whose great arches enframes the famous blaze that had destroyed much of London.[54] Old St. Paul's Cathedral, which eventually fell prey to the flames, dominates the skyline at the left. As in Turner's vignette, a number of boats can be seen on the river and figures crowd the right foreground. In Loutherbourg's picture, however, these figures are given greater prominence perhaps because of his background in stage design. Their histrionic gestures, vividly projecting human distress, were meant to stir the sympathies of viewers. The spatial separa-

64

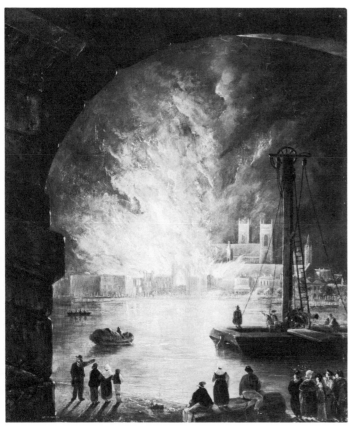

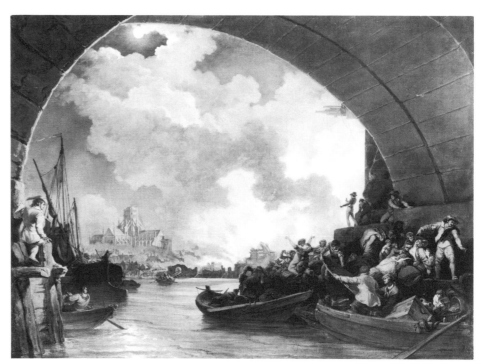

15 *Burning of the Houses of Parliament*. Great Britain, nineteenth century. Walters Art Gallery, 37.772.

Figure 50. Philip James de Loutherbourg, British, 1740-1812. *The Great Fire of London in 1666*. Oil on canvas, 23-5/8 x 32 inches, ca. 1797. Yale Center for British Art, Paul Mellon Collection, B1976.7.110.

tion of the action similarly recalls a stage setting—the fire serves mainly as a backdrop for the spectacle of grief and sorrow enacted in the narrow foreground plane.[55]

In contrast, Turner's vignette displays greater spatial unity. His figures, although essential for scale and human interest, do not overwhelm the subject, allowing instead a smooth flow from foreground to background. Loutherbourg portrayed a past event, beyond his personal experience, and so relied heavily on the actions of the figures to convey the impact of the 1666 fire. Having observed the Parliament fire

firsthand, Turner was able to give attention not only to conveying the human response to the event but to recreating the actual lighting and atmospheric effects he had personally witnessed. The result is yet another convincing portrayal of the monumentality of the scene. The sweep of Turner's imagination could not be restricted, even by the small-scale format of a vignette.

16 *Westminster from Waterloo Bridge*. Thomas Shotter Boys. The Cleveland Museum of Art, CMA 46.17.

Epilogue

Even as the Parliament fire was being extinguished and the damage surveyed, all thoughts were turning to the future. The *Examiner* commented, only two days after the fire:

> One good, however, remains to console us. The most wretched fires have generally left behind them some purification. The greatest fire known to London burnt down the city, but it burnt out the plague. Such a cure might be necessary, it is true, for that distemper, though we can scarcely think it so. A plague, however, will be got rid of—a plague of great annoyance. We shall at least have Houses fit for the dispatch of their great public business.[1]

In March 1835 a Select Committee began meeting to examine the question of rebuilding the Palace of Westminster.[2] The members of the committee announced their decisions the following June. They declared that the new place, incorporating Westminster Hall, should occupy the same site as the old, that its style should be either Gothic or Elizabethan, and that an open competition should be held to determine the architect.[3] The competitors would be required to submit their designs by November 1, 1835, allowing them five months to prepare their proposals. A Royal Commission of five members would then review the entries and report their findings to both Houses of Parliament.

Ninety-seven architects entered the competition. After deliberating for three months the Commissioners announced their selection, which they said had been based on a search for "grandeur of design, practicability, skill in arranging accommodation and attention to light and air."[4] They believed the plans submitted by Charles Barry (1795-1860), a versatile and energetic architect of some prominence, met these criteria.

No one was surprised by their choice, but a number of newspapers launched vehement attacks on the Commissioners' qualifications for making this important decision. Barry's design was also heavily criticized and some of the disgruntled competitors formally protested the award in a petition to Parliament.

The decision remained unchanged, however, and late in 1837, after Barry had submitted a more comprehensive set of drawings and worked out cost estimates, preparation of the building site began. By 1840 the river embankment had been completed and on April 27 Mrs. Barry laid the first stone of the new Palace.

The peaceful view of Westminster published two years later by Thomas Shotter Boys [16] indicates how slowly the work progressed. No new construction is visible around Westminster Hall because the foundations of the Houses were only just being set. Barry had originally thought the new Parliament buildings would be completed by this time, but the project encountered many delays: several caused by Parliament itself, others by the Fine Arts Commission supervising the artistic decoration of the palace, and still others by Dr. David Boswell Reid (1805-1863), a chemistry teacher appointed to oversee the heating and ventilation of the new structure. In addition to a mason's strike, there were also disputes over such matters as the design of the clock for the great tower and the size of the Royal Entrance. As a result the construction of the new Houses of Parliament took nearly twenty years altogether, though the House of Lords was ready for use in 1847 and the Commons Chamber in 1852.

The relationship between Charles Barry and his assistant,

Figure 51. John Anderson, British, active 1858-1884. *Westminster Bridge, The Houses of Parliament and Westminster Abbey seen from the River*. Oil on canvas, 72-1/4 x 42-1/4 inches, 1872. Museum of London, A 25910.

Augustus Welby Pugin (1812-1852), has also been the subject of considerable scrutiny. After the deaths of both men, their respective sons waged a rather unsavory "pamphlet war" over the true authorship of the building's design. Close examination of the available documents reveals that the overall conception and plan were Barry's, while Pugin, an extraordinarily gifted draftsman with a great talent for the use of Gothic ornament, was responsible for the decorative details. Their association was thus a true collaboration,[5] one that resulted in the multi-towered structure silhouetted against a dramatic sky in John Anderson's painting of 1872 (Figure 50). Just as the old buildings had represented traditions going back to the Middle Ages, the new Houses of Parliament came to be the focus of modern nationalistic pride in the growth and development of democracy in nineteenth-century Britain.

Notes to the Text

Notes for the Introduction

1. For a complete accounting of the artists who depicted either the fire or its aftermath see R. J. B. Walker, "The Palace of Westminster after the Fire of 1834," *The Walpole Society*, 44 (1974): 94-122.

2. Richard and Samuel Redgrave, *A Century of British Painters* (1866; reprint, London: Phaidon Press, 1947), p. 459.

3. Alfred Barry, *The Life and Works of Sir Charles Barry* (London, 1867; reprint, New York: Benjamin Blom, Inc., 1973), pp. 145-146.

4. August Welby Pugin to E. J. Willson, November 6, 1834. Fowler Collection, The Johns Hopkins University, Baltimore.

5. See C. R. Leslie, *Memoirs of the Life of John Constable* (1843; reprint, London: Medici Society, 1937), p. 320. A small painting, *A Fire in London from Hampstead* (oil on paper on panel, 3-3/4 x 6 inches), in the Paul Mellon Collection, Upperville, Virginia, was once thought to depict this fire, but that identifiction has been generally refuted and the picture dated to about 1826 to correspond with another study of a fire viewed from Hampstead listed at Christie's in 1892 as dating from 1826. See Basil Taylor, *Painting in London, 1700-1850: Collection of Mr. and Mrs. Paul Mellon*, exh. cat. (Richmond: Virginia Museum of Fine Arts, 1963), 1: 85, text; and Louis Hawes, *Presences of Nature, British Landscape 1780-1830*, exh. cat. (New Haven: Yale Center for British Art, 1982), pp. 191-192.

Notes for Part One: Turner: Life and Art

1. The Pantheon, designed by James Wyatt, was built in 1770-72.

2. No certain history of this picture, whose full title is *Battle of the Nile, at 10 o'clock when the L'Orient blew up, from the Station of the Gun Boats between the Battery and Castle of Aboukir*, is known. The available information is summarized in Martin Butlin and Evelyn Joll, *The Paintings of J. M. W. Turner*, 2 vols. (New Haven and London: Yale University Press, 1977). See cat. no. 10. All titles for Turner's works mentioned here correspond to those given by Butlin and Joll.

3. Two of his other works, the oil painting *Dolbadern Castle, North Wales* (Royal Academy of Fine Arts, Burlington House, London) and the watercolor *Caernervon Castle, North Wales* (British Museum), do, however, illustrate places associated with Welsh history. Both were accompanied by stanzas of poetry when exhibited. The one for *Dolbadern Castle* refers to the Welsh Prince Owen, who was imprisoned there for twenty-three years in the thirteenth century, while the stanza for *Caernervon Castle* refers to the conquest of Wales by England's King Edward I in 1282-83.

4. It has often been noted that the title of this picture is incorrect because the subject depicted is actually the *seventh* plague, hail and fire, rather than the fifth, pestilence. Apparently Turner was less interested in the text itself than its possibilities for dramatic interpretation.

5. A. J. Finberg, *The Life of J. M. W. Turner, R. A.* (Oxford: Clarendon Press, 1939), p. 66.

6. Ibid., p. 116. Turner might also have chosen this theme because of its popularity. As England was still involved in a naval war with France, Turner was aware that almost anything to do with ships and the sea was sure to excite public interest. Another possible inspiration may have been William Falconer's poem, *The Shipwreck*, originally published in 1762 and republished in 1804. See Butlin and Joll, p. 36.

7. For analyses of the shipwreck theme in nineteenth-century art see Lorenz Eitner, "The Open Window and the Storm-Tossed Boat: An Essay in the Iconography of Romanticism," *The Art Bulletin*, 37

(December 1955): 281-290, and T. S. R. Boase, "Shipwrecks in English Romantic Painting," *Journal of the Warburg and Courtauld Institutes*, 22 (1959): 337-344.

8. Turner originally planned to have a hundred landscape compositions in the series. Between 1807 and 1819 seventy plates were issued along with a frontispiece. Twenty plates were left uncompleted and plans for the final ten have been identified among Turner's drawings. See W. G. Rawlinson, *Turner's Liber Studiorum, A Description and a Catalogue* (London: Macmillan Co., 1878), and Gerald Wilkinson, *Turner on Landscape: The Liber Studiorum* (London: Barrie and Jenkins, 1982). Among the ramifications of this project is Turner's series of oil paintings of the 1840s that reworked some of the *Liber Studiorum* subjects. See Butlin and Joll, cat. nos. 509-515, 518-519.

9. The avalanche occurred in December 1808 at Selva, in the Grisons of eastern Switzerland. Twenty-five people were reported killed in a single cottage. According to Jack Lindsay, Turner was also inspired by a passage from "Winter" in James Thomson's poem, *Seasons* (1726), in which an avalanche is described. See Lindsay, *J. M. W. Turner: His Life and Work* (New York: Icon Editions, Harper & Row, 1966), p. 107.

10. In doing this Turner may have been reacting to a similar disaster scene, *An Avalanche in the Alps*, painted in 1803 by P. J. de Loutherbourg (1740-1812), which relied heavily on conspicuously theatrical figures to convey the terror of an avalanche.

11. The liberties Turner was taking with paint did not go unnoticed. A reviewer, writing for *The Sun*, June 12, 1810, commented: "The fall of an avalanche in the Grisons is not his usual style, but is no less excellent." Quoted in Finberg, p. 167.

12. For an analysis of Turner's early use of poetry see Jerrold Ziff, "Turner's First Poetic Quotations: an Examination of Intentions," *Turner Studies*, 2 (Summer 1982): 2-10, and Kathleen Nicholson, "Turner, Poetry, and the Transformation of History Painting," *Arts Magazine*, 55 (April 1982): 92-97.

13. Turner's *Fallacies of Hope* was never published as a single work, but remained a sequence of poetic fragments composed as captions for various pictures. Turner always considered the connection between painting and poetry to be vital.

14. Walter Thornbury, *The Life of J. M. W. Turner, R. A.*, rev. ed. (New York: Henry Holt and Company, 1877), p. 239.

15. The full title, *The Eruption of the Souffrier Mountains, in the Island of St Vincent, at Midnight, on the 30th of April, 1812, from a Sketch taken at the time by Hugh P. Keane, Esqre*, reveals that this was an event Turner had not personally witnessed. He relied on Keane's sketch and was probably also familiar with his account of the eruption, published in the October 1812 *Gentleman's Magazine*. In fact, Turner's rendering of the volcano corresponds closely to such details mentioned by Keane as light flashes "shooting upwards . . . like rockets of the most dazzling lustre," and "others like shells with their trailing fuses flying in different parabolas." See *Gentleman's Magazine* 82 (October 1812): 309.

16. Turner even stipulated in his will that *Dido Building Carthage* be left to the National Gallery in London, on the condition that it was to hang always between Claude's *Seaport: Embarkation of the Queen of Sheba* of 1648 and the *The Mill* of 1642.

17. In his fascination with nature's fire as manifested by volcanoes, Turner was following a tradition established in the eighteenth century when Joseph Wright of Derby (1734-1797) and P. J. Volaire (1729-1802) had both painted Mount Vesuvius in eruption. Turner did likewise, in two watercolors (Yale Center for British Art, Paul Mellon Collection, and Williamson Art Gallery, Birkenhead), both made in 1817, before his 1819 trip to Italy. They were probably based on sketches by other artists. Once in Italy, however, he did get a chance to witness and sketch Vesuvius in action. The spectacle impressed him enormously, but he never produced an oil version of the subject.

18. Quoted in *The Diary of Joseph Farington*, ed. Kathryn Cane, vol. 12, July 1812-December 1813 (New Haven: Yale University Press, 1983): 4224. Joseph Farington (1747-1821) was a topographical draftsman who was very influential in the Royal Academy. His detailed diary is one of the principal sources for the history of English art in the late eighteenth and early nineteenth centuries.

19. First introduced in 1809, the varnishing days allowed exhibitors time to varnish their pictures and apply any final touches. These three (later five) days were set aside for technical refinements just before the public opening of the exhibition.

20. The British Institution was founded in 1805 as an additional outlet for the exhibition of works by British artists. Unlike the Royal Academy, which was run entirely by artists, the British Institution was financed by a group of subscribers who had sole control of its affairs, including the choice and hanging of the exhibits. See Sidney C. Hutchison, *The History of the Royal Academy 1768-1968* (New York: Taplinger Publishing Company, 1968), p. 85.

21. The full title is *Snow Storm—Steam-Boat off a Harbour's Mouth making Signals in Shallow Water, and going by the Lead. The Author was in this Storm on the Night the Ariel left Harwich.*

22. According to Turner's friend, the Rev. William Kingsley, when he told the artist that his mother admired the picture, Turner replied that he had only painted it because he "wished to show what such a scene was like; I got the sailors to lash me to the mast to observe it; I was lashed for four hours and I did not expect to escape,

but I felt bound to record it if I did. But no one had any business to like the picture.'' Quoted in *The Works of John Ruskin*, ed. E. T. Cook and Alexander Wedderburn (London: George Allen, 1904), 13: 162. There may be some truth to Turner's story, but scholars have remained skeptical. Jerrold Ziff, in particular, has pointed out that at the time the picture was painted there was no steamer named *Ariel* servicing the port of Harwich. See Ziff, review of Martin Butlin and Evelyn Joll, *The Paintings of J. M. W. Turner*, in *The Art Bulletin*, 62, (March 1980): 170.

23. Richard and Samuel Redgrave. *A Century of British Painters*, 2 vols. (London: Smith, Elder and Co., 1866), 2:119-120.

Notes for Part Two: Dreadful Fire!

1. For a compilation of illustrations of the palace complex before the 1834 fire see Howard Colvin, ed., "Views of the Old Palace of Westminster," *Architectural History, The Journal of the Society of Architectural Historians of Great Britain*, 9 (1966): 23-184.

2. In 1384 Edward III established a religious brotherhood at Westminster, the College of St. Stephen, and granted it the Chapel of St. Stephen along with a cloister, gardens, orchards, and other buildings. In the sixteenth century the college was dissolved and its property passed to the crown. See Edward Wedlake Brayley and John Britton, *The History of the Ancient Palace and Late Houses of Parliament at Westminster*, hereafter referred to as Brayley and Britton, *Westminster* (London: John Weale, 1836), pp. 427-432.

3. The Court of Requests was traditionally convened by the "Masters of Requests," officers authorized to receive petitions for justice or favor from the King. See Brayley and Britton, p. 422. The room used for the Court of Requests had originally been used as a banqueting house; when Inigo Jones's Banqueting House was completed in Whitehall (1622), it was converted into the Court of Requests. R. J. B. Walker, "The Palace of Westminster after the Fire of October 1834," *Walpole Society*, 44 (1972-1974): 113.

4. These tapestries were completely destroyed in the fire of 1834. A set of engravings made by John Pine and published in 1739 preserves their imagery. Brayley and Britton, p. 423.

5. When William Rufus originally built the Hall, extending the original palace of Edward the Confessor, the main courtyard became known as Old Palace Yard. The courtyard in front of the newly erected Westminster Hall (separated from the river by the royal palace to the east) became known as New Palace Yard—the name still used today.

6. Brayley and Britton, p. 441.

7. Walker, p. 100.

8. J. W. Croker in *Minutes of Evidence Before the Select Committee*, May 1, 1833 (*Parliamentary Papers*, 1833 [269], xii, 545), quoted by M. H. Port in *The Houses of Parliament* (New Haven: Yale University Press, 1976), p. 5.

9. Sir John Soane, *Designs for Public and Private Buildings* (n.p., 1828). Reprinted in *Civil Architecture* (n.p., 1829), p. 8.

10. *Parliamentary Papers*, 1831 (308), iv, 655, quoted in Port, p. 9. The 1831 committee was chaired by Colonel Frederick William French.

11. The 1833 committee was chaired by Joseph Hume (1777-1855). See Port, p. 9.

12. Port, p. 12.

13. Plans were submitted by the following architects: Sir John Soane, Benjamin Wyatt, James Savage, William Kent, John Peter Deering, Adam Lee, Edward Blare, J. W. Croker, Francis Goodwin, Rigby Wason, MP, Decimus Burton, George Basevi, Sir Jeffrey Wyattville, George Allen, and Hanbury Tracy, MP. See Walker, p. 100.

14. Port, p. 13.

15. United Kingdom, Parliament, *Report of the Lords of the Council Respecting the Destruction by Fire of the Two Houses of Parliament with the Minutes of Evidence*, vol. 37, February 25, 1835, p. 3 (Readex Microprint).

16. See Hilary Jenkinson, "Exchequer Tallies," *Archaeologia*, 2d ser., 12 (1911): 367-380.

17. United Kingdom, *Privy Council Report*, p. 4 (*Minutes of Evidence*, October 20, 1834, p. 15). Phipps testified before the Privy Council that he thought the stoves of the House of Lords "a convenient and fit place," although he had never known them to be used to destroy wood rather than for heating with coal (p. 14).

18. Joshua Cross, whose regular work at the Houses of Lords and Commons was to attend to the water-closets and cisterns, had served three and a half years in the penitentiary at Millbank on charges of theft prosecuted by the Board of Works. He was rehired by the Board of Works on the basis of a character reference from prison authorities. Patrick Furlong was a day laborer. *Privy Council Report*, p. 38.

19. *Privy Council Report*, p. 4.

20. *Privy Council Minutes*, October 20, 1834, p. 35.

21. *Privy Council Minutes*, October 21, 1834. Another witness, John Jukes, the foreman of the works at the House of Lords, disputed this claim, p. 53.

22. *Privy Council Report*, pp. 5-6.

23. *Gentleman's Magazine*, 2 (November 1834): 477.

24. *Times*, October 17, 1834.

25. *Gentleman's Magazine*, 2 (November 1834): 482.

26. *Times*, October 17, 1834.

27. *Gentleman's Magazine*, 2 (November 1834): 477.

28. Ibid., p. 478.

29. *Times*, October 17, 1834.

30. Ibid.

31. Apparently at one point early in the evening Lord Duncannon had climbed up onto the roof of the House of Commons "to watch and superintend the play of the engines," placing himself in considerable danger "especially as he gallantly refused to leave the roof till all the firemen and soldiers who were with him had first descended." *Times*, October 17, 1834.

32. Ibid.

33. The manner in which the firefighting was handled was not held above reproach, however. The *Times* noted the lack of a general superintendent for the firefighting system as a whole, concluding that "our ordinary engines are totally incapable of contending with such a conflagration" and that the firefighting system wants the element of efficiency, a general superintendent. Each fire-office acts according to its own view; there is no obedience to one chief, and consequently when the completest cooperation is necessary all is confusion or contradiction" (October 17, 1834).

34. For a listing, see Walker, "The Palace of Westminster."

35. *Times*, October 18, 1834, p. 5.

36. The topographical draftsman, Robert William Billings (1815-1874), was a pupil of John Britton. Many of his drawings after the fire were used to illustrate Brayley and Britton's *Westminster*. Billings is also known for his drawings for *The Baronial and Ecclesiastical Antiquities of Scotland (1845-52)*. See Walker, p. 107.

37. Thomas Clark (active ca. 1834) exhibited theatrical designs, architectural views, and landscapes between 1827 and 1870. Some of his engravings were used in Brayley and Britton's *Westminster*. See Walker, pp. 106-107.

38. Museum of London, acc. no. 63.61. David Roberts was an architectural and travel painter. He made several versions of his oil painting of the Palace of Westminster viewed from the river. The only signed canvas belongs to the Chartered Insurance Institute, London. See Walker, p. 113.

39. *Times*, October 18, 1834.

40. *Privy Council Report*, p. 10.

41. The Council concluded that the fire was not the result of faulty design, but rather Mr. Weobley's failure to effectively superintend his workers and, in turn, their "gross neglect, disobedience of orders, and utter disregard of all warnings." Finally, the Council could not explain why Mrs. Wright "was not led by such manifest indications of danger to make immediate representations in the proper quarter." *Privy Council Report*, p. 6.

42. *Times*, October 18, 1834.

43. *A Portion of the Journal Kept by Thomas Raikes, Esq. from 1831 to 1847 Comprising Reminiscences in London and Paris during that Period*, new ed., 2 vols. (London: Longman, Brown, Owen, Longmans & Roberts, 1858), 1: 177.

44. The Six Acts included the Act for the Prevention of Unauthorized Military Training, the Seditious Meetings Act, the Newspaper Stamp Duties Act, and other laws designed to control the possession of arms and to hinder the expression of pro-reform sentiments. Goldwin Smith, *England: A Short History* (New York: Charles Scribner's Sons, 1971), p. 303.

45. *The Great Reform Bill, 1832*, exh. cat. (London: The National Portrait Gallery, 1973), text by Valerie Cromwell, p. 19.

46. Ibid., p. 22. See also Smith, p. 319.

47. Cromwell, in *Great Reform Bill, 1832*, p. 18.

48. For example, in 1867 the Representation of the People Act established nearly universal manhood suffrage in England, giving the vote to a much larger segment of the working class. In 1874 the vote was extended to rural workers (women were not enfranchised until 1918). See Smith, p. 356. On the significance of the Reform Bill, see also Walter L. Arnstein, *Britain Yesterday and Today, 1830 to the Present*, 4th ed. (Lexington, Mass.: D. C. Heath and Company, 1983), pp. 13-17.

49. The operation of the workhouse system was based on the view that if the working poor were to regain habits of self-respect, the workhouses must be as unappealing as possible. Thus, inmates were required to wear uniforms and husbands, wives, and children were separated. See Arnstein, p. 50. See also Sir Llewellyn Woodward, *The Age of Reform 1815-1870*, 2d ed. (Oxford: Clarendon Press, 1962), pp. 450-452.

50. Dickens also expressed the hatred of the poor towards this law in another novel, *Our Mutual Friend*, published in 1865.

51. *Times*, October 18, 1834, p. 5.

52. *Gentleman's Magazine*, 2 (November 1834): 477.

53. *Examiner*, October 17, 1834, p. 659.

54. Thomas Carlyle to Alexander Carlyle, October 24, 1834, in *Letters of Thomas Carlyle 1826-1836*, ed. Charles Eliot Norton (London and New York: Macmillan and Co., 1889), p. 455.

55. *Times*, October 18, 1834, p. 5.

56. *Cobbett's Weekly Political Register*, 1 November 1834, cols. 194, 268. William Cobbett's (1762-1835) inflammatory prose aroused great excitement among English workers who, following his lead, agitated for Parliamentary reform.

57. Charles Dickens, Speech to the Administrative Reform Association, June 27, 1855, in *The Speeches of Charles Dickens*, ed. K. J. Fielding (Oxford: The Clarendon Press, 1960), p. 206.

Notes for Part Three: Turner and the Burning of the Houses of Parliament

1. "Extract from the Shorthand Diary of John Green Waller, F. S. A.," transcribed by William J. Carlton, London University Library, Carlton College MS 317, fols. 54f. Waller, a painter, exhibited his work at the Royal Academy in London from 1835 to 1848. Clarkson Stanfield (1793-1867) was a marine and landscape painter.

2. A. J. Finberg, *A Complete Inventory of the Drawings of the Turner Bequest*, 2 vols. (London: Darling & Son, 1909), 2: 909, 910, 1207.

3. Andrew Wilton in *J. M. W. Turner*, exh. cat. (Paris: Éditions de la Réunion des musées nationaux, 1983), no. 224, p. 278, trans. by Wilton.

4. Gerald Wilkinson, *Turner's Color Sketches, 1820-34* (London: Barrie & Jenkins Ltd., 1975), p. 5.

5. Ibid., p. 12.

6. The remaining twenty-three pages in the book were left blank.

7. This anecdote comes from a letter written from Italy by John Soane, Jr., who came in contact with Turner in the neighborhood of Naples. See A. J. Finberg, *The Life of J. M. W. Turner, R. A.* (Oxford: The Clarendon Press, 1939), p. 262.

8. John Gage, *Colour in Turner: Poetry and Truth* (New York: Frederick A. Praeger, Publishers, 1969), p. 35.

9. W. Stokes, in R. G. Graves, *Studies in Physiology and Medicine* (1836), p. xi. quoted in Gage, *Colour in Turner*, p. 35, 36.

10. The Turner Bequest, left to the British nation, was in the care of the National Gallery, London, until the founding of the Tate Gallery in 1897. The unexhibited part of the Bequest was stored in the basement of the Tate until the Thames flood of 1928 precipitated the transfer of the drawings and sketchbooks to the Print Room of the British Museum. The observation that the Parliament sketchbook may have been affected by the flooding was made by Eric Harding of the British Museum's Department of Conservation. See Martin Butlin, review of the exhibition, "Romantic Art in Britain, Paintings and Drawings 1760-1860," *Master Drawings*, 6, no. 3 (Autumn 1968): 280.

11. During the 1810s and 1820s Turner had produced several hundred unfinished watercolors designated by scholars as "Color Beginnings" or "Color Structures." These appear to be no more than rough ideas, thoughts, observations, or experiments which he might later apply to more developed pictures. It is thus quite possible that the Parliament watercolors represent simply a continuation of this working method. On the other hand, in the forthcoming *Catalogue of English Paintings in the Philadelphia Museum of Art*, Richard Dorment attributes the variations among the watercolors to the many observation points from which Turner may have watched the fire. He has also outlined the sequence in which he believes the sketches were produced while Turner was at the scene.

12. Wilton, in Paris exh. cat., no. 224, p. 278.

13. Andrew Wilton has suggested that another fire was being recorded in the sketches—perhaps that which took place at Fenning's Wharf on the Thames at Bermondsey, in August 1836. A watercolor of that subject is in the Whitworth Art Gallery, Manchester (see Figure 11). Ibid.

14. John Gage has suggested that perhaps the engraving would have been published in one of Captain G. W. Manby's pamphlets on fire-fighting: "In his *Plan for the Establishment of a Metropolitan Fire Police* of January 1835, Manby drew extensively on his experience of the Parliament disaster, to emphasize the need for a unified fire-service to replace the private enterprise of insurance companies like the Sun Fire Office." See *J. M. W. Turner*, exh. cat. (Paris: Éditions de la Réunion des musées nationaux, 1983), no. 60, pp. 125-126, trans. by Gage.

15. *Gentlemen's Magazine*, November 1834, p. 478.

16. E. V. Rippingille, "Personal Reminiscences of Great Artists," *The Art Journal* (1860), p. 100, quoted in Finberg, *The Life of J. M. W. Turner*, pp. 351-352. William Etty (1787-1849), Augustus Wall Callcott (1779-1844), and Daniel Maclise (1806/11-1870) were all members of the Royal Academy along with Turner.

17. John Scarlett Davis to Joseph Ince, quoted in Walter Thornbury, *The Life of J. M. W. Turner, R. A.,* 2d ed. (New York: Henry Holt and Company 1877), pp. 452-453.

18. John Gage has pointed out that Turner himself felt this way and may have been influenced to do so by a series of concerts given in London by the great violinist Nicolo Paganini (1782-1840). Gage believes it quite likely that Turner attended these concerts, given during the summers of 1831-34, since he loved music and the theater. But even if Turner did not actually see Paganini perform, he undoubtedly heard that his brilliant playing was a continual source of amazement to his audiences. Gage notes a drawing of about 1830 (British Museum, TB CCLXIV-102) in which Turner "imagined himself as a drawing room performer at his easel." See Gage, *Colour in Turner*, pp. 170-171. For a comparison of Turner's ideas about painting with those of the "Action Painters" of the New York School of the mid-twentieth century see Lawrence Gowing, *Turner: Imagina-*

tion and Reality, exh. cat. (New York: The Museum of Modern Art, 1966), pp. 42-43.

19. Jack Lindsay, *J. M. W. Turner: His Life and Work, a Critical Biography* (Greenwich, Conn.: New York Graphic Society, 1966), p. 180.

20. Andrew Wilton has noted a painting by William Marlow (1740-1813), *The Waterworks at London Bridge on Fire*, exhibited in 1780 (Guildhall Art Gallery, London), which interestingly foreshadows the view and composition of the Philadelphia Turner. Letter to the author, December 22, 1982.

21. Gage notes that "the visual drama of a conflagration reflected in water had been a popular part of the repertory of London theatres since the early years of the century (see Sybil Rosenfeld, *Georgian Scene Painters and Scene Painting* [Cambridge: Cambridge University Press, 1981, pp. 118-119], and it is no surprise that this real and especially momentous fire should soon have become the subject of those quasi-theatrical entertainments, the Panorama and the Diorama." Paris exh. cat., no. 60, p. 125. As defined by Rosenfeld, pp. 155-156, the panorama, invented in 1787, consisted of "a series of views on a flat surface in a circular building." The diorama, invented by L. J. M. Daguerre in 1822, consisted of "dual pictures seen through a revolving auditorium. Once the audience had watched the changing lights in the first picture they were moved around on a turntable to view the second, so that it appeared as though the scene was gliding away and another succeeding it."

22. *Times*, October 17, 1834, p. 3.

23. Gowing, *Imagination and Reality*, p. 33. Another scholar has likened the scene to a "view into Hades with the river Styx teeming with the hapless souls of Londoners." See Lynn Robert Matteson, *Apocalyptic Themes in British Romantic Landscape Painting* (Ph. D. diss., University of California, Berkeley, 1975; Ann Arbor, Michigan: University Microfilms, 1980), p. 164.

24. John Canaday, *Mainstreams of Modern Art*, 2d ed. (New York: Holt, Rinehart and Winston, 1981), p. 95.

25. *Gentleman's Magazine*, 2 (November 1834): 478.

26. Martin Butlin and Evelyn Joll, *The Paintings of J. M. W. Turner*, 2 vols. (New Haven and London: Yale University Press, 1977), cat. no. 359.

27. See Lindsay, *Turner: His Life and Work*, pp. 112, 138-139.

28. See Eric Shanes, *Turner's Picturesque Views in England and Wales, 1825-1838* (London: Chatto and Windus, 1979), p. 18, nos. 35, 52, 53, 54, and 59.

29. Eric Shanes, "Turner in Cleveland," lecture delivered at The Cleveland Museum of Art, April 25, 1984.

30. Lindsay, *Turner: His Life and Work*, pp. 180-181. Lindsay considers another picture, *Prince of Orange, William III, embarked from Holland, landed at Torbay, November 4th, 1688 after Stormy Passage*, exh. 1832 (Tate Gallery), also to be a reference to the passage of the Reform Bill of 1832. See *The Sunset Ship: The Poems of J. M. W. Turner* (Lowestoft, Suffolk, England: Scorpion Press, 1966), pp. 61-62. See also Andrew Wilton, *J. M. W. Turner, His Art and Life* (New York: Rizzoli International Publications, 1979), pp. 218-219.

31. *Examiner*, October 19, 1834, p. 659.

32. Earlier examples of Turner's interest in spectacular current events include the two Pantheon drawings of 1792 (see Figures 1-2), the *Battle of the Nile*, exh. 1799, and the *Battle of Trafalgar*, exh. 1806. Turner painted a second *Battle of Trafalgar*, dated 1823-24, which was commissioned by George IV. See Butlin and Joll, cat. no. 252.

33. The full title of the painting is *Slavers throwing overboard the Dead and Dying—Typhon Coming On*. The incident of the slave ship *Zong* was recounted in T. Clarkson's *History of the Abolition of the Slave Trade*, originally published in 1808. A second edition, which Turner may have read, appeared in 1839. For a summary of the other possible sources for the theme of this picture see Butlin and Joll, cat. no. 385. When the painting was shown at the Royal Academy in 1840, Turner appended these lines from his *Fallacies of Hope*:

> Aloft all hands, strike the top-masts and belay;
> Yon angry setting sun and fierce-edged clouds
>> Declare the Typhon's coming.
>> Before it sweeps your decks throw overboard
>> The dead and dying—ne'er heed their chains.
>> Hope, Hope, fallacious Hope!
>> Where is thy market now?

34. See John Ruskin, "Modern Painters," *Works*, ed. E. I. Cook and Alexander Wedderburn, 39 vols. (London: George Allen, 1903-12), 3: 571-572.

35. Andrew Wilton, *Turner and the Sublime*, exh. cat. (London: British Museum Publications, for the Art Gallery of Ontario and the Yale Center for British Art, 1980), p. 99.

36. *Atheneum*, May 23, 1835, p. 395.

37. *Examiner*, March 8, 1835, p. 149.

38. *Atheneum*, February 14, 1835, p. 130.

39. *Literary Gazette*, February 14, 1835, p. 107.

40. *Morning Herald*, May 2, 1835, quoted in Butlin and Joll, cat. no. 364.

41. *Times*, May 23, 1835, quoted in Butlin and Joll, cat. no. 364.

42. *Fraser's Magazine for Town and Country*, 12, no. 67 (July 1835): 55.

43. John Ruskin, "Notes on the Turner Collection of Oil Pictures at the National Gallery," *Works*, 13: 161, no. 530.

44. *Times*, October 17, 1834, p. 3. Noted by Dorment, forthcoming *Catalogue of English Paintings*.

45. Typed memorandum, files of the Department of Later Western Art, The Cleveland Museum of Art. For more complete information on the history of ownership for the two paintings see Butlin and Joll, cat. nos. 359, 364.

46. Gowing, *Imagination and Reality*, p. 33.

47. In 1837 William Makepeace Thackeray (1811-1863) described the content of annuals such as the *Keepsake*, noting the usual "large weak plate" of a woman who "pats a greyhound, or weeps into a flower-pot, or delivers a letter to a bandy-legged page." Opposite is a poem entitled "The Forsaken One of Florence," by L. E. L. or Miss Mitford or Lady Blessington, "about water-lilly, chilly, stilly shivering beside a streamlet, plighted, blighted, love-benighted, falsehood sharper than a gimlet, lost affection, recollection, cut connexion, tears in torrents, true-love token, spoken, broken, sighing, dying girl of Florence." See *Fraser's Magazine for Town and Country*, 16, no. 96 (December 1837): 757. See also Gordon N. Ray, *The Illustrator and the Book in England from 1790 to 1914* (New York: The Pierpont Morgan Library, 1976), p. 40.

48. The Honorable Mrs. Norton, ed., *The Keepsake for MDCC-CXXXVI* (London: Longman, Rees, Orme, Brown, Green, and Longman, 1835), p. 295. See Introduction for excerpt from poem.

49. Basil Hunnisett, *Steel-Engraved Book Illustration in England* (London: Scolar Press, 1980), p. 76. Willmore also engraved *A Fire at Sea* after another Turner vignette for the same edition of *The Keepsake* (p. 159) which makes an interesting comparison with Turner's 1835 oil of the same subject (see Figure 13). A third vignette after Turner, *The Wreck*, engraved by Griffiths, also appeared in *The Keepsake* this same year (p. 273).

50. Turner's first use of the vignette was in illustrations for Samuel Roger's *Italy* (1830), but at that time he used a horizontal, rectangular format. For the Scott illustrations he turned to the upright oval. Adele Holcomb has defined the unique quality of the vignette as "a form which does not imply a window onto space but is created by the relative emergence of forms from an indeterminate matrix." See "The Vignette and the Vortical Composition in Turner's Oeuvre," *Art Quarterly*, 33 (Spring 1970): 17.

51. *Times*, October 17, 1834, p. 3.

52. Dorment, forthcoming *Catalogue of English Paintings*.

53. The artist may have been a follower of Henry Pether (1828-1865), who was noted for his moonlit views of the Thames. See William R. Johnston, *The Nineteenth Century Paintings in the Walters Art Gallery* (Baltimore: Trustees of the Walters Art Gallery, 1982), p. 197.

54. For other depictions of the Great Fire see *1666 and Other London Fires*, exh. cat. (London: Guildhall Art Gallery, 1966).

55. Depictions of fires were often seen in Loutherbourg's Eidophusikon, first performed in 1781. The Eidophusikon was a miniature theater, almost like a peep show, in which natural phenomena were convincingly imitated through the use of transparencies, movable scenery, and sound effects. It is quite possible that the youthful Turner may have seen one of these performances. See *Philippe Jacques de Loutherbourg, 1740-1812*, exh. cat., Kenwood, The Iveagh Bequest (London: Greater London Council, 1973).

Notes for the Epilogue

1. *Examiner*, October 19, 1834, p. 659.

2. The question as to where Parliament would convene in the interim had been resolved in short order. In February 1835, less than four months after the fire, temporary accommodations were ready: the Lords moved into the refurbished Painted Chamber and the Commons moved into the Court of Requests, formerly the House of Lords. This decision, to retain the governmental seat in the midst of the rebuilding site, only made the work more difficult.

3. The decision to rebuild the Houses of Parliament in a medieval rather than a classical style was the focus of heated debate. The arguments in favor were mainly based on national assertiveness, since Gothic was generally considered a British invention while Elizabethan was associated with Shakespeare, Bacon, and other national heroes. For a summary of contemporary attitudes toward the choice of the Gothic style for the Houses of Parliament see M. H. Port, ed., *The Houses of Parliament* (New Haven and London: Yale University Press, 1976), pp. 30-32.

4. R. J. B. Walker, "The Palace of Westminster after the Fire of October 1834," *Walpole Society*, 44 (1972-1974): 104.

5. Phoebe Stanton, "Barry and Pugin: A Collaboration," in M. H. Port, ed., *The Houses of Parliament*, p. 71.

Catalogue

J. M. W. Turner

1 *The Fifth Plague of Egypt.*

Etching and mezzotint, from the *Liber Studiorum*, 11-3/4 x 16-3/8 inches, 1807-08. Rawlinson 16, state I/III. The Cleveland Museum of Art, Gift of Miss Katherine Bullard, in memory of Francis Bullard, CMA 19.135.

2 *Coast of Yorkshire near Whitby.*

Etching and mezzotint, from the *Liber Studiorum*, 11-3/4 x 17 inches, 1807-1811. Rawlinson 24, Proof. The Cleveland Museum of Art, Gift of Miss Katherine Bullard, in memory of Francis Bullard, CMA 19.141.

3 *Little Devil's Bridge Over the Russ above Altdorft Swiss^d.*

Etching and mezzotint, from the *Liber Studiorum*, 11-3/4 x 17-1/4 inches, 1807-09. Rawlinson 19, state I/III. The Cleveland Museum of Art, Gift of Miss Katherine Bullard, in memory of Francis Bullard, CMA 19.137.

4 *London from Greenwich.*

Etching and mezzotint, from the *Liber Studiorum*, 11-5/8 x 17-3/8 inches, 1807-1811. Rawlinson 26, state I/III. The Cleveland Museum of Art, Gift of Miss Katherine Bullard, in memory of Francis - Bullard, CMA 19.143.

5 *The Woman and the Tambourine.*

Etching and mezzotint, from the *Liber Studiorum*, 11-3/4 x 16-5/8 inches, 1807-1819. Rawlinson 3, state I/IV. The Cleveland Museum of Art, Gift of Miss Katherine Bullard, in memory of Francis - Bullard, CMA 19.124.

6 *Burning of the Houses of Parliament.*

Watercolor, 9-1/4 x 12-3/4 inches, 1834. London, Trustees of the British Museum, TB CCLXXXIII-2.

7 *Burning of the Houses of Parliament.*

Watercolor, 9-1/4 x 12-3/4 inches, 1834. London, Trustees of the British Museum, TB CCLXXXIII-5.

8 *Burning of the Houses of Parliament.*

Watercolor, 9-1/4 x 12-3/4 inches, 1834. London, Trustees of the British Museum, TB CCLXXXIII-6.

9 *Burning of the Houses of Parliament.*

Watercolor, 9-1/4 x 12-3/4 inches, 1834. London, Trustees of the British Museum, TB CCLXXXIII-9.

10 *Burning of the Houses of Parliament.*

Watercolor, 17-3/4 x 11-3/4 inches, 1834. London, Trustees of the British Museum, TB CCCLXIV-373.

11 *Burning of the Houses of Parliament.*

Oil on canvas, 36-1/4 x 48-1/2 inches, 1835. Philadelphia Museum of Art, John H. McFadden Collection, M'28-1-41.

12 *Burning of the Houses of Parliament.*

Oil on canvas, 36-1/2 x 48-1/2 inches, 1835. The Cleveland Museum of Art, Bequest of John L. Severance, CMA 42.647.

13 *Destruction of Both Houses of Parliament by Fire Oct^r 16, 1834.*

Watercolor, 5-1/2 x 4-3/8 inches, vignette, ca. 1835. Englewood, Colorado, Museum of Outdoor Arts.

James Tibbetts Willmore, British, 1800-1863.

14 *Destruction of Both Houses of Parliament by Fire Oct^r 16, 1834*, after J. M. W. Turner.

Engraving, 4-7/16 x 3-9/16 inches, vignette, 1835. Reproduced in *The Keepsake for MDCCCXXXVI*, 1835. Cleveland, Case Western Reserve University, Freiberger Library.

Great Britain, nineteenth century.

15 *Burning of the Houses of Parliament.*

Oil on panel, 14 x 12 inches, ca. 1834. The Walters Art Gallery, Baltimore, 37.772.

Thomas Shotter Boys, British, 1803-1874

16 *Westminster from Waterloo Bridge.*

Lithograph printed in colors with watercolor added by hand, from the series *London As It Is*, 6-5/16 x 17-15/16 inches, 1842. The Cleveland Museum of Art, Gift of Mrs. Ralph Perkins in memory of Coburn Haskell, CMA 46.17.

Selected Bibliography

I. Turner

Butlin, Martin. *Turner: Watercolours*. New York: Watson-Guptill, 1962.

Butlin, Martin, and Evelyn Joll. *The Paintings of J. M. W. Turner*. 2 vols. New Haven and London: Yale University Press for the Paul Mellon Center for Studies in British Art and The Tate Gallery, 1977.

Cust, Lionel. "The Portraits of J. M. W. Turner, R. A."*The Magazine of Art*, 18 (1895): 245-251.

Finberg, A. J. *A Complete Inventory of the Drawings of the Turner Bequest . . .* 2 vols. London: Darling & Son, 1909.

_____. *The Life of J. M. W. Turner, R. A.* Oxford: The Clarendon Press, 1939.

Finley, Gerald. *Turner and George the Fourth in Edinburgh, 1822*. London: The Tate Gallery, 1981.

Gage, John, ed. *Collected Correspondence of J. M. W. Turner*. Oxford: The Clarendon Press, 1980.

_____. *Colour in Turner: Poetry and Truth*. New York: Frederick A. Praeger, 1969.

Gaunt, William, with notes by Robin Hamlyn. *Turner*. Rev. and enl. ed. Oxford: Phaidon Press, 1981.

Gowing, Lawrence. *Turner: Imagination and Reality*. Exh. cat. New York: The Museum of Modern Art, 1966.

Hermann, Luke. *Turner: Paintings, Watercolors, Prints & Drawings*. London: Phaidon Press, 1975.

J. M. W. Turner. Exh. cat. Paris: Éditions de la Réunion des musees nationaux [for the Galeries nationales du Grand Palais], 1983.

Lindsay, Jack, ed. *The Sunset Ship: The Poems of J. M. W. Turner*. Lowestoft, Suffolk, England: Scorpion Press, 1966.

_____. *J. M. W. Turner, His Life and Work: A Critical Biography*. Greenwich, Conn.: New York Graphic Society, 1966.

Paulson, Ronald. *Literary Landscape: Turner and Constable*. New Haven and London: Yale University Press, 1982.

Rawlinson, W. G. *The Engraved Work of J. M. W. Turner, R.A.* 2 vols. London: Macmillan Co., 1913.

_____. *Turner's Liber Studiorum, A Description and a Catalogue*. London: Macmillan Co., 1878.

Reynolds, Graham. *Turner*. New York and Toronto: Oxford University Press, 1969.

Rothenstein, John, and Martin Butlin. *Turner* New York: George Braziller, 1964.

Shanes, Eric. *Turner's Picturesque Views in England and Wales, 1825-1838*. Introduction by Andrew Wilton. London: Chatto & Windus, 1979.

Thornbury, Walter. *The Life of J. M. W. Turner, R. A.* Rev. ed. New York: Henry Holt and Company, 1877.

Turner, 1775-1851. Exh. cat. Essays by Martin Butlin, Andrew Wilton, and John Gage. London: The Tate Gallery, 1974.

Walker, John. *Joseph Mallord William Turner*. Concise edition. New York: Harry N. Abrams, 1983.

Weelen, Guy. *J. M. W. Turner*. New York and London: Alpine Fine Arts Collection, 1982.

Wilkinson, Gerald. *The Sketches of Turner, R. A., 1802-20: Genius of the Romantic*. London: Barrie & Jenkins, 1974.

_____. *Turner on Landscape: The Liber Studiorum*. London: Barrie & Jenkins, 1982.

_____. *Turner's Color Sketches, 1820-34*. London: Barrie & Jenkins, 1975.

_____. *Turner's Early Sketchbooks: Drawings in England, Wales and Scotland from 1789 to 1802*. London: Barrie & Jenkins, 1972.

Wilton, Andrew. *J. M. W. Turner: His Art and Life*. New York: Rizzoli International Publications, 1979.

_____. *Turner Watercolors from The British Museum*. Exh. cat. Washington, D.C.: International Exhibitions Foundation, 1977.

_____. *Turner and the Sublime*. Exh. cat. London: British Museum Publications for The Art Gallery of Ontario, The Yale Center for British Art, and The Trustees of The British Museum, 1980.

_____. *Turner in the British Museum: Drawings and Watercolors*. Exh. cat. London: British Museum Publications for The Trustees of The British Museum, 1975.

II. English History and the Houses of Parliament

Arnstein, Walter L. *Britain Yesterday and Today: 1830 to the Present*. 4th ed. Lexington, Mass.: D.C. Heath and Company, 1983.

Bell, Aldon. *London in the Age of Dickens*. Norman, Okla.: University of Oklahoma Press, 1967.

Brayley, Edward Wedlake, and John Britton. *The History of the Ancient Palace and Late Houses of Parliament at Westminster*. London: John Weale, 1836.

Colvin, Howard, ed. "Views of the Old Palace at Westminster." *Architectural History, the Journal of the Society of Architectural Historians of Great Britain*, 9 (1966): 23-184.

The Great Reform Bill 1832. Essay by Valerie Cromwell. Exh. cat. London: National Portrait Gallery, 1973.

MacDonagh, Michael. *The Book of Parliament*. London: Ibister and Company, 1897.

Pope-Hennessey, James. *The Houses of Parliament*. London: Michael Joseph, 1945.

Port, M. H., ed. *The Houses of Parliament*. New Haven and London: Yale University Press for the Paul Mellon Center for Studies in British Art (London), 1976.

1666 and Other London Fires. Exh. cat. London: Guildhall Art Gallery, 1966.

Smith, Goldwin. *England: A Short History*. New York: Charles Scribner's Sons, 1971.

Stanley, Arthur Penrhyn. *Historical Memorials of Westminster Abbey*. 2 vols. New York: Anson D. F. Randolph & Company, n.d.

Walker, R. J. B. "The Palace of Westminster after the Fire of October 1834." *Walpole Society*, 44 (1972-74): 94-122.

Wright, Arnold, and Philip Smith. *Parliament Past and Present*. London: Hutchinson & Co., 1902.